From my archives:

Maiden Aunts & Other Trifles

From my archives:
Maiden Aunts & Other Trifles

JOHN EBDON

MARSHALL PICKERING

To the memory of my friend and mentor
Nigel Hollis

First published in Great Britain in 1990 by Marshall
Pickering

Marshall Pickering is an imprint of the Collins
Religious Division, part of the Collins Publishing
Group, 8 Grafton Street, London W1X 3LA

British Library Cataloguing in Publication Data
Ebdon, John
 From my archives: Maiden Aunts and Other Trifles
 1. Christian life
 I. Title
 248.4

 ISBN 0-551-02001-6

Designed by Marion Morris

Printed in Great Britain by Richard Clay Ltd,
Bungay, Suffolk

Further and further from old pangs I tread
And see what once were anguish, fear and hope
Turn to the faint still shapes of memory.
I am like some climber down a headlong slope
Who, traversing fell and field after his climb,
Sees from the distant plains at evening time
The far clear range against the flowing sky;
He marks the rocks where he was hard bestead,
Where he dared all, in breathless, strained delight,
Turned into cloudland at the fall of night;
All wrapped in the impenetrable gleam,
Serene, and insubstantial as a dream.

<div align="right">Margaret Cropper</div>

Contents

Acknowledgements

The author acknowledges with thanks permission to reproduce copyright material as listed below.

ABP (Methuen Books) for the extract from *The World We Live In* by Helen Keller.

Collins Fount for the thirteenth chapter of St Paul's Epistle to the Corinthians from *The New Testament in Modern English* translated by J B Phillips.

Constable Publishers for 'Iam, Dulcis Amica' from *Medieval Latin Lyrics* by Helen Waddell.

John Murray (Publishers) Ltd for 'Christmas' from *Collected Poems* by John Betjeman.

SCM Press Ltd for 'Who Am I?' from *Letters and Papers from Prison* by Dietrich Bonhoeffer.

In the case of other material used, efforts to contact the copyright-holders have not been successful.

Foreword

ADVICE FROM A CATERPILLAR

The Caterpillar and Alice looked at each other for some time in silence: at last the Caterpillar took the hookah out of its mouth, and addressed her in a languid, sleepy voice.

'Who are you?', said the Caterpillar.

This was not an encouraging opening for a conversation. Alice replied, rather shyly, 'I – I hardly know, sir, just at present – at least I know who I was when I got up this morning, but I think I must have been changed several times since then.'

'What do you mean by that?', said the Caterpillar sternly. 'Explain yourself!'

'I can't explain *myself*, I'm afraid sir,' said Alice, 'because I'm not myself, you see.'

'I don't see', said the Caterpillar.

'I'm afraid I can't put it more clearly,' Alice replied very politely, 'for I can't understand it myself to begin with; and being so many different sizes in a day is very confusing.'

'It isn't', said the Caterpillar.

'Well, perhaps you haven't found it so yet,' said Alice; 'but when you have to turn into a chrysalis – you will some day, you know – and then after that into a butterfly, I should think you'll feel it a little queer, won't you?'

'Not a bit', said the Caterpillar.

'Well, perhaps your feelings may be different,' said Alice; 'all I know is, it would feel very queer to *me*.'

'You!', said the Caterpillar contemptuously. 'Who are *you*?'

Which brought them back again to the beginning of the conversation. Alice felt a little irritated at the Caterpillar's making such *very* short remarks, and she drew herself up and said, very gravely, 'I think you ought to tell me who *you* are, first.'

'Why?', said the Caterpillar.

Lewis Carroll, *Alice in Wonderland*

THIS BOOK BEGAN AS A COMPILATION of my favourite pieces of prose, poetry, saws and sayings – snippets of enjoyment which I have amassed and read throughout my formative years. But it has developed into more than an excuse for serendipity.

Unwittingly I have been enticed into opening a box of personal recollections in which were stowed, dusty and undisturbed, the more poignant milestones in my life. Many had been forgotten or wilfully overlooked, but when I lifted the lid of that benign Pandora's urn, the remembrances flew

out and embraced me like so many ghosts. Not all were welcoming spectres. Not all were happy. Life, as I have discovered, is not a carnival; but nostalgia wafted out on a heady cloud and I inhaled deeply of it.

I was reminded of my initial encounter with death and the first intimation of our mortal nature. Of the agony of puberty when I fell in love for the first time and was rejected out of hand, when my seventeen-year-old heart was shattered into a thousand fragments and I wrote dreadful verses in the tomb of my room and, like Rachael of old, would not be comforted. I remembered my first doubts of the existence of God and the feeling of emptiness as I wandered for a year across the arid desert of disbelief in company with other nomadic agnostics, searching for, but not finding, an oasis of faith. On a happier note I relived the day when I became a father, and I recalled the kindness and toleration which my own parents unstintingly gave to me. Sorrow, joy, hope, doubt and fear, tears and laughter, all were remembered.

Thick and fast they came, those reminiscences of yesteryear, and like a man watching the countryside fly by from an express train, I saw my life flash past and was drawn unwillingly into the web of introspection. And within it I learned a salutary lesson. Although I now know *what* I am, I am still far from discovering *who* I am. Nor, for fear of what I may unearth, do I think I shall pursue the hunt for this particular veracity. 'Let sleeping truths lie', cries the craven within me. 'Rest untroubled under your blanket of illusion!'

Agreed, my friends tell me who they *think* I am and, on balance, the image is not too unpalatable to my ego. But they only see what I *wish* them to see. The truth is that only God

knows who I am, and He is the only real judge. And when the great day comes and I stand before the fictional pearly gates and come face to face with my Maker, I hope He will smile benignly and say, 'Well, my dear chap, at least you didn't do any actual harm.' But I draw consolation that far greater men than I have been exercised by similar thoughts. A short time before his unjust and barbarous execution by the Nazis in a German prison during the last world war, Dietrich Bonhoeffer wrote this poem:

Who am I? They often tell me
I stepped from my cell's confinement
Calmly, cheerfully, firmly,
Like a squire from his country-house.
Who am I? They often tell me
I used to speak to my warders
Freely and friendly and clearly,
As though it were mine to command.
Who am I? They also tell me
I bore the days of misfortune
Equably, smilingly, proudly,
Like one accustomed to win.

Am I then really all that which other men tell of?
Or am I only what I myself know of myself?
Restless and longing and sick, like a bird in a cage,
Struggling for breath, as though hands were
 compressing my throat,
Yearning for colours, for flowers, for the voices of
 birds,

Thirsting for words of kindness, for neighbourliness,
Tossing in expectation of great events,
Powerlessly trembling for friends at an infinite
 distance,
Weary and empty at praying, at thinking, at
 making,
Faint, and ready to say farewell to it all?

Who am I? This or the other?
Am I one person today and tomorrow another?
Am I both at once? A hypocrite before the others,
And before myself a contemptibly woe-begone
 weakling?
Or is something within me still like a beaten army,
Fleeing in disorder from victory already achieved?

Who am I? They mock me, these lonely questions of
 mine.
Whoever I am, Thou knowest, O God, I am thine!

So spoke one of the uncanonised saints of our century.
 But now onward – however reluctantly – grow old along
with me!

All the world's a stage,
And all the men and women merely players:
They have their exits and their entrances;
And one man in his time plays many parts,
His acts being seven ages. At first the infant
Mewling and puking in the nurse's arms.

And then the whining schoolboy, with his satchel,
And shining morning face, creeping like snail
Unwillingly to school. And then the lover,
Sighing like furnace with a woeful ballad
Made to his mistress' eyebrow. Then a soldier,
Full of strange oaths, and bearded like the pard,
Jealous in honour, sudden and quick in quarrel,
Seeking the bubble reputation
Even at the cannon's mouth. And then the justice,
In fair round belly with good capon lin'd,
With eyes severe, and beard of formal cut,
Full of wise saws and modern instances;
And so he plays his part. The sixth age shifts
Into the lean and slipper'd pantaloon,
With spectacles on nose and pouch on side,
His youthful hose well sav'd a world too wide
For his shrunk shank; and his big manly voice,
Turning again towards childish treble, pipes
And whistles in his sound. Last scene of all,
That ends this strange eventful history,
Is second childishness, and mere oblivion,
Sans teeth, sans eyes, sans taste, sans everything.

As You Like It

Retrospection

Grow old along with me!
The best is yet to be,
The last of life, for which the first was made:
Our times are in His hand
Who saith 'A whole I planned,
Youth shows but half; trust God: see all nor be
 afraid! . . .'

Then, welcome each rebuff
That turns earth's smoothness rough,
Each sting that bids nor sit nor stand but go!
Be our joys three-parts pain!
Strive, and hold cheap the strain;
Learn, nor account the pang; dare, never grudge
 the throe!

For thence – a paradox
Which comforts while it mocks –
Shall life succeed in that it seems to fail;
What I aspired to be,
And was not, comforts me:
A brute I might have been, but would not sink
i' the scale . . .

Let us not always say
'Spite of this flesh today
I strove, made head, gained ground upon the
 whole!'

As the bird wings and sings,
Let us cry 'All good things
Are ours, nor soul helps flesh more, now that flesh
 helps soul! . . .'

But I need, now as then,
Thee God, who mouldest men . . .

So take and use Thy work!
Amend what flaws may lurk,
What strain o' the staff, what warmpings hast the
 aim!
My time be in Thy hand!
Perfect the cup as planned!
Let age approve of youth, and death complete the
 same.

 Robert Browning

CUPID-LIPPED, BLUE-EYED AND FAIR-HAIRED and with other features like those of a Botticelli angel, the girl child gazed at my face with unwavering concentration, mutely listening as her uncle and I conjured up memories of boyhood days long past. I found her quite enchanting. How gratifying, I thought as I watched her from the corner of my eye, that our nostalgic ramblings should enthral her so completely. There was, I pondered, much good in the modern child despite

widely held opinions to the contrary and I congratulated myself on my success as a spellbinder. For a long, long while she eyed me in silence, her head cradled in her hands and her little finger tentatively exploring her right nostril. Then, as I arrested my reminiscing to light my pipe, she spoke.

'Excuse me,' she said with exquisite politeness and an engaging lisp, 'but do you know you've a hair growing out of the top of your ear?'

Next to her my contemporary coughed, tried hard but failed to expunge a smile with his hand, while disbelievingly and with a dented ego I stared glassily at her through the swirling tobacco smoke and allowed my match to peter out. 'No' I said, 'I didn't. Where?' 'There,' said she, pointing toward the target area, 'there.' Slowly I guided my finger and thumb toward the member under discussion. 'Um,' she said, her eyes brightening with encouragement as I found the exhibit, 'that's it – the long black crinkly one.' She paused. Then: 'That means you're getting old, doesn't it?' I nodded bleakly, my self-esteem continuing to evaporate. 'Yes,' I said, 'I suppose it does', and swallowed hard. 'Um,' she repeated no less unsympathetically and still staring at me unblinkingly, 'my friend Isabelle says her gran'pa's got lots of crinkly black hairs growing out of his ears *and*', she added coyly, 'other places. You see,' she continued blissfully and uninhibitedly, 'she's seen him in his bath.' She paused again while I digested the intelligence. Then without malice but delicately placing a verbal rapier between my ribs, she administered the *coup de grâce*. 'Tell me,' she asked, 'What's it feel like to be old? *Really* old I mean?' I was forty-six at the time.

Twenty years have passed since she afforded me that *mauvais*

quatre d'heure and happily we are still good friends. She has a no less outspoken daughter of her own and I have joined the ranks of the Senior Citizens. I have retired as Director of the London Planetarium, collected my Travel Permit and flashed its sepia photograph suggesting that the camera had clicked shortly after I had been exhumed before benevolent ticket collectors; I have had my first taste of the idiocy and bureaucracy of the DHSS, received the first payment of my State Pension and, *Deo gratias*, been given the luxury of having time to 'stand and stare' as William Davies bade me do; and to think. No more is life one long headache in a busy street, as Masefield once said it was, and no longer am I harnessed to the hands of a clock. I have discovered the inestimable joy of being Time's master and not its slave. In short, life is good, and I look forward even more eagerly than I did during my frenetic days to what the morrow will bring. But I also look back and turn the pages of the scrapbook of my life.

Not all the revelations are happy ones. Contrary to the wistful recollections of many of my peers and seniors the sun did not shine daily undisturbed in cloudless skies of bygone summers. Sometimes old age conveniently blunts the memory and erases truth but that fortuitously is nature's way of things. Paramountly we remember the good times and forget the bad; but good and ill fortune sit cheek by jowl and we grow in strength because of it. Sadness gives way to joy; out of despair springs hope and, platitudinous though it may be, courage is born of adversity. Thus our lives and characters are fashioned by this emotional pot-pourri and it cannot be otherwise. Life, as Ogden Nash observed in a verse entitled 'You and Me and P.B. Shelley', is complex and often anomalous.

What is life? Life is stepping down a step or sitting in
a chair,
And it isn't there.
Life is not having been told that the man has just waxed
the floor,
It is pulling the doors marked Push and pushing the doors
marked Pull and not noticing the notices which may say
Please Use the Other Door.
Life is an Easter Parade
In which you whisper: No darling, if it's a boy we'll call
him after your father! into the ear of a most astonished
stranger, because the gentleman you thought was
walking beside you has stopped to gaze in a window full
of 'How to improve your putting' manuals.
It is when you diagnose a sore throat as an unprepared
geography lesson and send your child weeping to school
only to be returned an hour later covered with spots that
are indubitably genuine,
It is a concert for unaccompanied trombone filling in
for Yehudi Menuhin.
Were it not for frustration and humiliation
I suppose the human race would get ideas above its
station.
Somebody once described Shelley as a beautiful and
ineffectual angel beating his luminous wings against the
void in vain,
Which is certainly describing him with might and main,
But probably means that we are all brothers under our
pelts
And Shelley went around pulling doors marked Push and

19

pushing doors marked Pull just like everybody else.

And four hundred years before Mr Nash put whimsical pen to paper, Sir Walter Raleigh also mused on man's mortal coil albeit in a different metre.

> What is our life? A play of passion;
> Our mirth the music if division;
> Our mothers' wombs the tiring houses be
> Where we are drest for this short comedy.
> Heav'n the judicious sharp spectator is
> That sits and marks still who doth act amiss.
> Our graves that hide us from the searching sun
> Are like drawn curtains when the play is done.
> Thus march we playing to our latest rest
> Only we die in earnest, that's no jest.

But let us not dwell on 'graves, of worms, and epitaphs' but upon the beginning of life – with the miracle of birth!

Birth

Our birth is but a sleep and a forgetting;
The Soul that rises with us, our life's Star,
Hath had elsewhere its setting,
And cometh from afar.

William Wordsworth,
'Intimations of Immortality'

I WISH THAT I COULD HAVE BEEN COGNIZANT of my birth; to have been aware of the sensations as, urged by my mother, I slipped from within the moist, warm, dark walls of her womb and into the glare of the unknown to begin my journey through life. I wish I could have heard my bellowed proclamation of creation, the cries of approbation from the doctor and midwife, and recall the joy of my mother as, dried and swaddled, I was offered to her breast to be held in admiration. I wish that I could remember pursing my toothless lips and sending a groping mouth toward the nipples where the opaque milk was ready. Above all, I wish I could recapture the moment when I was loved for the first time.

The birth of a child is important. It is the pay day of love,

or so I reflected when I looked upon my firstborn an hour after her arrival in a Nairobi hospital. Looking not unlike Tenniel's drawing of the Duchess's baby in *Alice in Wonderland* and showing every promise that like that infant she would turn into a piglet at any moment, she was no beauty. Her ears were large, her nose porcine, and she was very pink; but she was perfect in every particular and I gazed in awe at her tiny wrinkled feet and hands complete with unblemished nails and marvelled at the consummation of God's handiwork. 'Look,' I said to my wife as I held our daughter in my arms, 'no joins.'

To believers every birth is a miracle, the visual manifestation of the power of God when a new soul is brought into the world, and for some the event makes a greater impact than on others. For Laurie Lee the birth of his first child near to Christmas in 1964 enriched his life and moved him to philosophic thought.

Christmas is two-faced, of course – a great double festival which the ages have rolled into one: part an act of bravado held in the teeth of winter, part the Christian celebration of birth.

The old pagan part always seemed reasonable to me, a raising of spirits when things looked black. Eat, drink and be merry, it seemed to say, the sun is extinguished, and tommorrow we die.

But the newer part, the festival of birth, seemed somehow to have got there by accident. Surely the spring, I thought, was the proper time for all this, and not the bleak midwinter – April or May, when everything on

earth was being born and bursting out all round me.

I realise now that things are right as they are, that spring can look after itself, that the Holy Child was born in the pit of winter because it was the time of our greatest need, when the search had been longest, hope almost abandoned, and most of the signs of life obscured.

Others may have known all this for 2,000 years – but we each need a personal revelation. I am seeing it now for the first time in my life – and a longish life at that – because after twelve years of marriage, and a long winter of doubt, my first child has just been born.

Nothing is so remarkable as that which happens to oneself, commonplace as it may be to others. And the truth of a love story never quite makes sense until you yourself are in love.

For Christmas is the family, and the family is the child, and without the child the light of Christmas is blurred. And now that this light, for me, has been suddenly switched on, I see all I'd forgotten – or never knew. For the birth of a child saves us all from extinction, is in fact almost a resurrection; still more precious perhaps, in my case at least, for having been so long and coldly awaited.

So as a brand-new parent – in spite of all the years I've lived through – this is the first true Christmas of my life. Till now, it was a feast without a blessing, a candle without a flame; now I can see round its gaudy commercial drapes, through its stupors of over-eating, back to the original child, whose feast this is, standing smiling at the beginning of things.

And everything now falls sparkling into place, the carols seem written for us alone, my child stares at the tree, her eyes full of lights, and it is the first Christmas tree for us both.

The moment can't last. My child will grow up, I suppose. The lights of this tree will fade. But it doesn't matter. Christ is born every year and remains the point of our return, the chance to revisit this date, its star and its cradle, the miracle lying within it, and to share together, mortal though we both may be, this moment of brief eternity.[1]

To be born as I was like Laurie Lee's child close to Christmas Day, on what astrologers determine as being on the cusps of the zodiacal signs of Saggitarius and Capricorn was, I discovered, a mixed blessing. On the debit side the date afforded aunts both great and maiden the opportunity to press gifts upon me with the unpleasing announcement 'This is for your birthday *and* Christmas, dear', leaving me with a feeling of acute injustice and that I had been cheated outrageously. However, there were compensations. 'How kind,' I mused when I was five and naively believing that all the preparations for the festival were being made especially for me, 'how wonderfully kind of people to go to all this trouble'; and I revelled in tinsel and happiness and nothing robbed me of my euphoria.

Over sixty Christmases have passed since I enjoyed that childish conceit. Some were spent in Kenya; some in India; and some in Switzerland. But none, not even the ambience of the Bernese Oberland, produced the magic of those spent

in a village in the south-east of England. It was an unexceptional community but I hold fond memories of it, and of one character in particular – Old Jack. Close on eighty-seven and a native of Norfolk by birth he was a splendid old man with hands as gnarled as the vines he used to tend when he was head gardener in one of the big Sussex houses, and even in old age his blue eyes twinkled from his leathery face. His faith was very simple and his theology Aristotelian. So far as he was concerned there *was* 'a home for little children above the bright blue sky', and one for little ole men too if they behaved themselves. But he thought the sputniks had no right up there 'messing about with they hangels' and he said as much to the vicar. And despite his years and arthritic limbs, each Sunday found him at the altar rail to ' 'ave a little ole drink with the Lord' as he put it.

Devout old Jack had a way with words and he never minced them. His general vocabulary may have been impoverished but his command of basic English was indisputable although I never once heard him blaspheme. He spoke his mind and did so one Advent to a sour-faced woman in the village store who announced that Christmas was a waste of money and meant nothing to her. 'Then it bloody orter,' he snorted, ' 'cos it's the time when little ole Jesus was born – and don't you bloody forget it missus. And,' he added, glaring after the lady as she departed hurriedly, clasping a packet of artificial snow marked 'Xmas Greetings', and pointing to the bag, 't'aint bloody *Hex*mas neither – it's *Christmas*.' And he turned to me and chuckled. 'That told 'er,' he said, 'stoopid old besom.'

I know how he felt. I also have an abhorrence for the unattractive plastic face of Xmas. So too did a Mrs Julia

Ackroyd who heard me broadcast on the subject and who wrote me a 'Ballade of Seasonal Regrets'. It read thus:

Guy Fawkes is over. How to fleece them now?
Exploit the season of Goodwill and Gain!
'Buy!' scream the merchants, and we all kow-tow,
The frenzied advertisers go insane.
'The kiddies need a supersonic train,
A doll which walks and weeps and wets its bed,
A festive missile-firing aeroplane!'
And 'Xmas' rears once more its ugly head.

It's not the way it used to be, somehow,
Although the ancient truths unchanged remain.
The carol singers made their usual row,
They said for victims of our hurricane
(Quite likely true, but hard to ascertain)
And simple trust eludes the overfed
Knee deep in tinsel, broken toys and strain,
As 'Xmas' rears once more its ugly head.

One wonders, just *how* sacred is this cow?
For recently I heard some folk complain
'They're dragging Jesus into Christmas now!'
Do they not spend and drink and gorge in vain?
Blow but the chaff, and in the palms the grain,
The seeds of love which make our daily bread.
So why should we reap chiefly stomach-pain
As 'Xmas' rears once more its ugly head?

ENVOI

Prince, do I seem a Scrooge, or inhumane?
The church roof leaks since someone stole the lead.
Yet we'll rejoice His birth with might and main
Though 'Xmas' rears once more its ugly head.

I gave that ballade to Old Jack to read. He pored over it for a very long time. Then he spoke. 'Aaah,' he said, 'Aaah.'

That Christmas time and others in the village were happy ones and I have joyful memories of them: of the Primary School Nativity Play in the village hall when catarrhal shepherds bellowed 'Follow the star', and perspiring Magi tripped over their robes and Melchior's make-up ran; of the year Baby Jesus's head came off and a tearful Mary was clobbered by Joseph; and the never to be forgotten Advent when the inn keeper departed from his script. 'Come in,' he cried to the inquiring couple, 'there's plenty of room inside!' 'Sod me,' said Old Jack from the back of the hall, 'that's buggered it up for sure.' And the Head Teacher tore her hair in the wings and the curtain came down on bedlam.

I remember, too, the carol singers. For me there will always be the mystery of sudden voices in the dark, however indifferently they sing. But there they sang well outside my cottage before taking their bobbing storm lantern on a pole down the lane to another house. And the smells of a country Christmas remain with me; the pungent, saturnalian scents of holly, laurel, mistletoe and fir; not stale apologies with withering berries bought from London barrows at inflated

prices, but freshly cut and taken from the countryside to decorate the church on Christmas Eve.

Christmas Eve! The one day in the year when the word 'bedtime' did not ring unpleasantly in my children's ears. To climb the stairs on Christmas Eve was no hardship for them, but an embarkation for the land of hope and expectation which the following day would bring with its ecstasy of promise. When the parcels and packages stacked around the tree would be handed out, and even the cat had a present and the same wand-clutching faded fairy that topped the trees of my childhood would stare open-eyed and at a drunken angle at the happiness below her.

Christmas is the child's time, and rightly so. But I recall these Christmas Eves for the walks with my wife to the little church close to the woods, and the ringing of its bell for the midnight mass; for the candlelight and the crowded pews, and the extra chairs which narrowed the aisle for the 'twice-a-yearers' to sit on; for choirboys' faces, pink and shining and with the devil scrubbed out of them for an hour; for the singing of carols which everyone knew, of 'Adeste Fideles' raising the roof, and the joy on the face of the Vicar. 'Happy Christmas!' we cried out, one to the other, at the service's end, and some of us embraced. Then out into the night we would go, chattering and laughing, and back to separate homes. But we had worshipped as one family. As Old Jack said to me the year before he died: 'That's Christmas my ole boy – not bloody *Xmas*.'

It was; but there have always been Scrooges lurking in the holly to spoil our fun. In the nineteen-twenties this notice appeared in a daily paper: 'The Chief Constable has issued

a statement declaring that carol singing in the streets by children is illegal, and morally and physically injurious. He appeals to the public to discourage the practice.' The declaration was read by many, including G.K. Chesterton who replied:

God rest you merry gentlemen,
Let nothing you dismay;
The Herald Angels cannot sing,
The cops arrest them on the wing,
And warn them of the docketing
Of anything they say.

God rest you merry gentlemen,
Let nothing you dismay:
On your reposeful cities lie
Deep silence, broken only by
The motor-horn's melodious cry,
The hooter's happy bray.

So, when the song of children ceased
And Herod was obeyed,
In his high hall Corinthian
With purple and with peacock fan,
Rested that merry gentleman;
And nothing him dismayed.[2]

And the final score? Chief Constable, nil – G. K. Chesterton, 1.

Enigma

A babe is born all of a may
 To bring salvation to us.
To him we sing both night and day
 Veni creator Spiritus.

At Bethlehem, that blessed place,
 The child of bliss now born he was;
And him to serve God gave us grace,
 O lux beata Trinitas.

There came three kings out of the east
 To worship the king that is so free,
With gold and myrrh and frankincense,
 A solis ortus cardine.

The angels came down with one cry
 A fair song that night sung they
In the worship of that child:
 Gloria tibi Domine.

So runs the traditional and well loved version of the Nativity.
But now, in the twentieth century, contemporary poets suck
their pens pensively and furrow their brows asking:

Was it the way they say? With wise men queuing,
Having been star-led into Bethlehem?
Hosannas in the air, and trouble brewing
From smooth tongued Herod, interviewing them?

31

Did Herod really tremble for his throne?
Did cattle kneel and angels flutter down
And gold change hands? And were sweet spices blown
Along the alleys of that little town?

Or was it really just a simple matter,
Simply a birth not to be set apart?
Mary, Joe's wife, with friends surrounding her,
Secretly rather tired of all this chatter,
Holding a little shyly, to her heart,
The new apprentice to a carpenter?[1]

LIKE THE POOR, IN SOME CIRCLES controversy about the divinity of the Christchild and the authenticity of the scriptural account of the journey of the Magi is always with us, as is exampled in the poem 'Anno Domini' by Eric Millward. No less predictable is the hoary, annual evergreen concerning the truth about the Star of Bethlehem. What was it? A miracle, a 'sign' given to the Magi for them alone to see? Or was it a physical experience? And, if so, why was the event mentioned only by Matthew who as an ex-tax-collector was unlikely to have been given to flights of fancy? Moreover, it is a question beset with other problems, for despite the best endeavours and scholarship of historical theologians the exact year of the Nativity is still not known for sure: nor is the precise date. What is certain is that our Lord was not born exactly 2,000 years ago and unequivocably not on December 25th, a statement which once caused me to be attacked physically in the London Planetarium by a woman with a red umbrella who advised me shrilly that I had ruined her Christmas,

shattered her belief and that she was going to remove all her decorations forthwith. Nevertheless what I said was correct although I was saddened by the thought that her faith hinged on a date. However, if we assume that the Blessed Virgin gave birth between the years 4 and 7 BC, i.e. toward the end of Herod's reign, we can consider two possibilities; but prior to that we need clarification on the role and definition of the Magi.

Firstly, the Magi were the 'wise men' of their time. They were men schooled in astronomy, who studied the skies and the stars scientifically and who had the ability to calculate planetary movements, eclipses, conjunctions and occultations; but they also embraced astrology. As many still do today, they believed that the moon, sun, planets and stars were influential and, like many of our contemporaries, were always looking for signs and portents. For example, if two planets appeared to come together in conjunction, that had astrological significance. So, too, had the appearance of a comet, or solar and lunar eclipses. And in the year reckoned as 7 BC a phenomenon of that nature did take place. The planets Jupiter and Saturn, the 'wandering stars' as they were known, conjuncted. And they came together not once but three times between the May and December of that year.

Astronomically that would have come as no surprise to the Jewish astronomers/astrologers in Babylon: by calculation they would have known that the event was going to occur. Nor, merely on the strength of a triple conjunction, would they have made a long and tedious journey to Palestine to see from there that which they could have observed equally well from Babylon. But *astrologically* there was every reason. Astrologically *one* conjunction was significant, let alone three.

Furthermore, there was the belief that Jupiter was the Royal Star, and Saturn, according to Jewish tradition, was the protector of Israel. In addition to these omens the 'meetings' took place against the constellation of Pisces the Fishes which, also in Jewish tradition, was the zodiacal sign of Israel and gave credence to the prophecy that the arrival of a messiah would be heralded by such a happening. 'This', the Magi may have argued, 'is evidence that a King has come to Israel. Let us go and see for ourselves.'

Now if we continue this line of thought, it is safe to assume that the Magi would not have begun their trek during the intense heat of May. But if they had set out on October 1st, the date of the second conjunction, or even waited until the third of that month – the Jewish Day of Atonement – they would have arrived in Jerusalem and given their news to Herod by the end of November. From there an uneasy Herod, unwelcoming of the idea of any opposition to his rule and acting on the advice of scribes who told him it had been prophesied that a Messiah would be born in the city of David, sent them to Bethlehem. And as they went in the twilight of a December evening, the third conjunction would have taken place. And in the words of Matthew, 'the star . . . went before them.'

So much for that theory. On the other hand if our Lord was born in 5 BC there is the possibility that the enigma was a nova – an existing, inconspicuous star undiscernible with the naked eye, which flares up suddenly with great brilliance for a comparatively short time. And in that year the Chinese recorded such a star. It blazed out for seventy days against the constellation of Aquila the Eagle – the hated ensignia of the Roman legions – and would certainly have been visible

in the Mediterranean area. Who knows? It could have been that. Personally I do not believe it matters one jot or one iota what the Star of Bethlehem was. Nor, academic considerations apart, do I think it matters if Christ was born in October, November or December in 7, 4 or even 11 BC when a comet appeared giving us yet another alternative. So far as I am concerned the importance lies not in the symbol or the date, but in the birth – the greatest birth of all.

> The bells of waiting Advent ring,
> The Tortoise stove is lit again
> And lamp-oil light across the night
> Has caught the streaks of winter rain
> In many a stained-glass window sheen
> From Crimson Lake to Hookers Green.
>
> The holly on the windy hedge
> And round the Manor House the yew
> Will soon be stripped to deck the ledge,
> The altar, font and arch and pew,
> So that the villagers can say
> 'The church looks nice' on Christmas Day.
>
> Provincial public houses blaze
> And Corporation tramcars clang,
> On lighted tenements I gaze
> Where paper decorations hang,
> And bunting on the red Town Hall
> Says 'Merry Christmas to you all'.
>
> And London shops on Christmas Eve
> Are strung with silver bells and flowers

As hurrying clerks the City leave
To pigeon-haunted classic towers,
And marbled clouds go scudding by
The many-steepled London sky.

And girls in slacks remember Dad
And oafish louts remember Mum,
And sleepless children's hearts are glad,
And Christmas-morning bells say 'Come!'
Even to shining ones who dwell
Safe in the Dorchester Hotel.

And is it true? And is it true,
This most tremendous tale of all,
Seen in a stained-glass window's hue,
A Baby in an ox's stall?
The Maker of the stars and sea
Become a Child on earth for me?

And is it true? For if it is,
No loving fingers tying strings
Around those tissued fripperies,
The sweet and silly Christmas things,
Bath salts and inexpensive scent
And hideous tie so kindly meant;

No love that in a family dwells,
No carolling in frosty air,
Nor all the steeple-shaking bells
Can with this single Truth compare –
That God was Man in Palestine
And lives today in Bread and Wine.[2]

<div align="right">John Betjeman</div>

Growing Up

The day I could no longer walk with ease
Beneath the table, made it clear to me
That I was growing. Soon my parents' knees
Were well below my eye-line. I could see
Above the window-sill and out, far out,
Into a world where adults knew it all
And children yearned to grow and be about
Such fascinating business. To be tall
Held out a promise greater than mere size.
When I achieved full stature I would know
Those peaks of knowledge conquered by the wise –
All that remained for me to do was grow.
Yet wisdom gained shows wisdom still ahead;
Grown up, I find I'm growing down instead.[1]

<div align="right">Mary Spain</div>

THE ADAGE 'OUT OF THE MOUTHS OF BABES AND SUCKLINGS' is
no empty cliché. If you want the truth on any matter, and
particularly on personal affairs, ask a child and you will receive
a clear-cut, straight and unadulterated answer. It is intinctive
for a child to tell the truth, the whole truth and nothing but

the truth, whereas as we grow to maturity truth would appear to be the very last possession with which we want to part; and with good reason. Should we do so there would be fewer successful candidates for the Diplomatic Service and possibly by now we should have become embroiled in a third World War. That is not to say that in the diplomatic areas of the world and divers summit conferences, all men are liars – far from it; but the hard school of life and their professions has obliged them to be 'economical with the truth' as one of our politicians put it. But with children it is a very different matter. Agreed, as they mature they learn to temper their remarks or at least to keep their thoughts to themselves, a reality which may have inspired Hilaire Belloc to write a short verse entitled 'Grandmama's Birthday' which begins:

> Dear Grandmama, with what we give
> We humbly pray that you may live
> For many, many happy years;
> Although you bore us all to tears.[2]

Verbum sap. However, at the age of seven, my elder son, still unaware of the social niceties which compel us to camouflage our thoughts in society, did less well. 'Thank you very much indeed,' said he, opening a present in front of the donor and apprising himself of its contents with undisguised displeasure, 'just what I didn't want.' It was an unpleasant episode and one which afforded me acute embarrassment. But, as I reminded myself later, the gaffe which he committed with his unbridled tongue was no more than poetic justice; in Switzerland and at a similar age I too had caused hurt and havoc among my elders by my frankness and lack of inhibition.

38

'But *why*', shrieked a formidable and totally resistible Swiss woman dressed in black bombazine and who, with a hirsute upper lip, moved in an aura of stale mothballs, 'will you not kiss me, *mon petit chou*?' 'Because', said her *petit chou*, fiercely repulsing her attempts to embrace him and displacing her pince-nez the while, 'your moustache pricks me and you smell of old clothes.'

It was an unhappy moment in our family history and particularly for my nanny who was privy to my enormity. Unfairly, in my opinion, those in authority adjudged her guilty by default of playing a major part in the event, which led to the severing of diplomatic relations between my mother and the outraged Madame Fournier. She should, it was argued, have prevented me from giving tongue; and, if necessary, by force. None the less, she remained in my mother's employ and I became indebted to her. Nanny Françoise introduced me to astronomy.

Although clearly not a product of the Norland Stables – indeed she originated from a small village in the Jura – she was a lovable, deeply religious and surprisingly erudite person possessed of three consuming interests: Dutch gin; the stars; and myself; and in that order of priority. Consequently, nearly every star she saw was a binary, and most of the planets and constellations which swam into her ken were blurred at the edges. Also, much of which she told me was wholly inaccurate; but it was through her that my appetite for the subject was whetted. It was she who guided my eyes to beyond the frosted roofs of La Chaux-de-fonds and into the dark Swiss skies where swung the Great and Little Bears around the stationary Pole Star; and it was she who showed me the fire-fly beauty of the

Pleiades, the Seven Sisters and the majesty of Orion the Hunter, the Nimrod of the Bible. 'Ah,' she would whisper, her arms around my shoulders in the cold night air, 'are they not wonderful, *mon petit homme*, those tiny stars? And was it not clever of *le bon Dieu* to have put them there?'

More than half a century has passed since those innocent childhood days, and Nanny Françoise has long since departed from this planet. But on winter nights when the frost is keen and the stars shine out like diamonds, her ghost stands by me in the darkness looking upward, and once again I hear her voice: 'Are they not wonderful, those tiny stars?' And I think of the words of Emerson which unknowingly she echoed: 'If the stars should appear one night in a thousand years, how would men believe and adore; and preserve for many generations the City of God which had been shown!'

And perhaps Emerson, in turn, had been influenced by the words of the nineteenth psalm of David to the Chief Musician:

> The heavens declare the glory of God
> And the firmament showeth her handiwork.
> Day unto day uttereth speech,
> And night unto night showeth knowledge.

Parents

My little Son, who look'd from thoughtful eyes
And moved and spoke in quiet grown-up wise,
Having my law the seventh time disobey'd,
I struck him, and dismiss'd
With hard words and unkiss'd,
His Mother, who was patient, being dead.
Then, fearing lest his grief should hinder sleep,
I visited his bed,
But found him slumbering deep,
With darkened eyelids, and their lashes yet
From his late sobbing wet.
And I, with moan,
Kissing away his tears, left others of my own:
For, on a table drawn beside his head,
He had put, within his reach,
A box of counters and a red-vein'd stone,
A piece of glass abraded by the beach,
And six or seven shells,
A bottle with bluebells,
And two French copper coins, ranged there with
 careful art,
To comfort his sad heart.

So when that night I pray'd
To God, I wept, and said:
Ah, when at last we lie with tranced breath,
Not vexing Thee in death,
And Thou rememberest of what toys
We made our joys,
How weakly understood
Thy great commanded good,
Then, fatherly not less
Than I whom Thou has moulded from the clay
Thou'lt leave Thy wrath, and say,
'I will be sorry for their childishness.'

Coventry Patmore

COVENTRY PATMORE'S POEM written, it is believed, about his eldest son Milnes and noted down in the red heat of inspiration without a single correction, brings to my mind a parallel concerning one of my own sons; but with one difference. I awoke Christopher and we forgave each other, and then went to sleep – happy. To paraphrase Saint Paul's advice to the Ephesians, there is much to be said for not letting the sun go down upon one's wrath.

Coventry Kersey Dighton Patmore was a mid-Victorian, and patently one with a lesser understanding of children than a later generation of fathers. However, in mitigation, when one considers the agony of despair in which this acutely sensitive man was left after the death of his first wife; when

reported himself as 'cheerfully waiting to die' and later, 'somewhat impatiently waiting to die', then one can understand his feelings. Outbursts of sudden anger would be followed by deep remorse, conflicts in his nature of which he was fully aware; but these moods did leave him unfit to look after his children.

No such humours scarred my father, although he was a strict disciplinarian, albeit a scrupulously fair man. In retrospect I owe much to him. By profession he was a soldier, a field officer in an unfashionable but distinguished regiment of foot. However, despite that handicap, he was remarkably articulate and well read. By contrast with my mother – a beautiful woman from the French-speaking part of Switzerland, a Genevoise, tall and elegant with shapely ankles, and blessed with a wicked tongue and the ability to dress well on a limited budget – my father was short, stocky, and when out of uniform managed without effort to give the impression that he had slept in his clothes during a long period of hibernation; but despite a trenchant wit, and unlike my mother, he was never calculatingly hurtful with words. As a staunch Nonconformist he feared both God and the Pope, but for different reasons; was deeply suspicious of men who wore after-shave lotion; conspicuously stood to attention during the playing of the National Anthem; and always removed his hat when passing the Cenotaph. He also retained his tie at all times regardless of climatic conditions; and never showed his braces. He was, as the French would say, '*très propre*'.

My father's philosophy of life was refreshingly uncomplicated. Either one 'played the game' or one did not.

Those who kept to the rules were gentlemen, regardless of their social status, and those who ignored them were cads or bounders. To these categories were admitted men who wore old school ties to which they were not entitled, and commissioned officers in the Home Guard who retained and used their ranks in peace time. His objection to that practice was once made abundantly clear to an official of the Gas Light and Coke Company Ltd, to such good effect that it was only with difficulty that the shamed and sometime Major was dissuaded from putting his head into one of his own ovens. But he did leave the district.

Equally beyond the pale were those who left their seats during overs at Lords or who gave tongue at Twickenham when conversions were being attempted. Such things were 'not done', which is why I am glad my father is no longer with us, for nowadays they are; and sport is the poorer for both gestures. Nor would he have approved of the current trends of questioning the validity of the Virgin Birth and of denigrating one's own country, for whilst privily he was not adverse to voicing uncharitable thoughts about the efficiency of the Cabinet and, God save the mark, that of the MCC, he would never proclaim his reservations in public; and certainly not before foreigners. That, too, was 'not done'. What he would have had to say about the ordination of women and the elevation of that sex to episcopal status is another matter, but I shudder at the thought.

He was a splendid mentor. By example he taught me how to pray; the meaning of honesty; how to apologise and to admit when I was in the wrong. He showed me how to gather and

pass a Rugby ball when I was seven, and at the same age instructed me how to hold a cricket bat. He applauded me roundly when I broke two scullery windows in quick succession off his under-arm deliveries with a soft ball, mollified our general factotum who was working at the sink at the time by bribing her with a shilling; and by spanking me soundly for kicking my wicket in a fit of pique he instilled in me the importance of accepting an umpire's decision at all times, and of being a good loser. As I was seldom allowed the luxury of being a good winner this advice was to prove invaluable.

Although, unlike the late General Montgomery, my father never referred to God as 'that Great Umpire in the Sky' or prayed that he be allowed to 'hit the enemy for six', much of his vocabulary was made up of sporting metaphors. Shortly before he died, unpleasantly but with a quiet dignity from cancer in a cottage hospital, I visited him and looked with sadness at the yellowing echo of the man who had authored me. His eyes were still blue but rheumy with age and illness and his pipe lay untouched and unwanted in a glass ash-tray beside his bed.

I stayed for a while, holding his hand and talking quietly in a desultory fashion about trivialities, until he closed his eyes and dozed, and in his half sleep returned to the Somme and Flanders fields and mumbled the name of his younger brother who had fallen as others had done in bloodied heaps at Menin, in the war to end all wars. And he called upon his father and the King and cried out for stretcher-bearers, and spoke the names of Larwood and Verity. And so I waited with him as the spectres of half a century flitted through his muddled mind,

and the gold half-hunter on his bedside table ticked away the minutes of his life.

It was when I disengaged my hand and eased myself from his bed that he reawakened. I said softly: 'I think it's time I went now. See you tomorrow, if that's all right?' The blue eyes looked hazily but directly at me under half-lowered lids. 'Yes,' he said, 'yes, of course. But I think it's time I was getting back to the pavilion too.'

He gave a little sigh like that of a tired child at the end of a long day. 'After all,' he said, 'I've been at the crease for quite a while you know, quite a while. I've had a very good innings.' And gently turning his head away, he smiled into the pillow.

Later that evening I was told that he had died and for a long while I mourned his passing, for with his death, or so it seemed to me, a little greenness had gone from the land and I miss him still. As a friend of mine observed, it is a strange feeling when one realises that one has become the older generation. But I drew comfort from this quotation which he sent me through the post.

Death is nothing at all. I have only slipped away into the next room. I am me and you are you, whatever we were to each other we are still.

Call me by my old familiar name, speak to me in the easy way which you always used. Put not sadness into your tone, wear no air of sorrow. Laugh as we always laughed at the little jokes we enjoyed together.

Play, smile, think of me, pray for me. Let my name

be the household word that it always was. Let it be spoken without effort or grief, life means all that it ever meant, it is the same that it ever was, that is absolute certainty.

What is death but a negligible accident. Why should I be out of mind because I am out of sight? I am waiting for you for an interval somewhere very near just around the corner.

All is well.

<div align="right">Canon Scott Holland
(1847 – 1918)</div>

All is very well. My father's generation may be clay but many of his qualities and those of his contemporaries are manifest in their heirs. Men of his calibre, but younger in age, are still to be found in our cities, villages and country towns, and without them many a church would be found wanting for wardens and many a voluntary organisation short of staff. These are they who, as their fathers did, still carry the torch of the Christian faith and ensure that its light burns brightly. These are they who obey the command, 'Go and serve the Lord', but who seldom make news in the popular press, for prurience gains greater attention than goodness. 'Sex-crazed Drug Addict rapes Woman of Eighty' makes a bigger and more saleable headline than 'Youth Club Members help Old Age Pensioners'; but it always has. And the young have always been maligned.

'Our youth', wrote one apoplectic, 'has bad manners, disregards authority and has no respect whatsoever for age;

today's children are tyrants; they do not get up when an elderly man enters the room; they talk back to their parents; they are just *very bad*.'

His name? Socrates. Nothing changes. His sentiments have been, and will be, repeated through the ages. And as future generations come and go, the same cry will go up from Land's End to John O'Groats; for that is the way of the world. But equally it is true to say that we can find more good in the world than badness – *if* we have a mind to.

Schoolmasters

Some man one day, a better man than I am,
Will look into your eyes and lose his heart,
And quoting, maybe, bits of Omar Khayyam
Will take you (sans the loaf of bread) apart
'Neath some convenient bough to sing your praises,
And lover-like, still gazing in your eyes,
Inform you with a fierceness that amazes
That you are very beautiful and wise.

But could he see you now aged nine or under,
Your pleasant placid face untouched by care,
Would he not call, with me, on earth to sunder
And swallow you complete with desk and chair?
Would he not share with me some fellow-feeling
As I devise, with inward rage, a fate
That may convince you, though it lead to squealing,
That 5 + 4 does not result in 8!

<div style="text-align: right">F. A. V. Madden</div>

'MY BOY,' SAID MY MATHEMATICS MASTER one wet May
morning as he eyed me with thinly veiled malevolence over

rimless half-glasses after yet another unproductive lesson in elementary algebra, 'I am told that your Latin is passable; that your Greek is good, and that you have a way with words, whatever' – and here he paused to allow his eyebrows to approach his hairline – 'that may mean. But permit me to advise you', he continued acidly as they returned to their normal position, 'that the only advantage of an aptitude for the Classics is that it will enable you to despise the wealth it will prevent you from earning.' And so saying, slowly he ran the tip of his tongue across tight mean lips and smiled, mirthlessly. As I was to discover in maturity his statement lacked originality, but upon that day it found its mark. I dug my finger nails deep into my palms, turning my knuckles white, and wished him to perdition.

He was an unpleasant, small man with thin, oiled black hair low parted and stranded economically across a balding head, and possessed of a stained fly-front to his trousers. Uncharitable boys said he was incontinent but for my part I limited my character assassination of him by entertaining the fancy that like one of Shakespeare's murderers he had been born with teeth.

However, his assessment of my intellectual strengths and foibles was accurate in every particular. Like poor little Miss X, mathematics in all branches of the discipline were anathema to me, and words did come readily to my lips. And he was correct in his appreciation of my love for the myths and men of ancient Greece, excluding it must be said those mathematical giants Euclid and Pythagoras and others of their calling. Never once was I moved to emulate Archimedes and to rush naked from my bath and through the school quadrangle crying 'Eureka! Matron, come and see – my

body weight in water's left the tub!' Nor, unlike him, did I care a fig if any person cast a shadow on my circles, although I was sorry that a Roman sword had ended his deliberations in Syracuse with such indecent haste. But oh! those other heroes of that bygone age – how I was drawn to them!

In my mind's eye and aided by my classics tutor, an actor *manqué* of some forty years, a genius who made cold print leap from a page and into reality, I sailed with Jason in the Argo in search of the fabled Golden Fleece, charged with Achilles in the Trojan wars, flew with Perseus on the back of Pegasus and was at Hercules's side when he captured the Cretan Bull and brought it on his back across the sea to Argolis. These were the men who filled my boyhood dreams and helped me pass away long hours during other lessons in stuffy classrooms heavy with the smells of chalk dust and stale Stephen's ink, and I minded not that the stories were untrue. Nor, in those early teenage days, was I distressed by the moral behaviour of some of the gods although it did seem to me that Chronos with his sickle went a little too far with his father even though he was only doing what Mother told him. And with regard to Zeus I found most of his encounters with women, both mortals and immortals, innocent enough. As a naive and late physical developer I saw no badness in him turning himself into a cuckoo in order to be with Hera, or, for that matter, assuming the guise of a swan so that he might enjoy the company of Leda. Both seemed nice enough girls and I could well understand his wish to know them better; and once I had crossed the threshold of pubescence and fallen in love with my house-master's daughter, a virtuous young woman ten years my senior, I envied him his power of metamorphosis.

But until that moment when I yearned for ichor in my veins and craved for Asclepius's balm to rid me of my acne I was content to gaze through a classroom window to see, not unclad elms revealing naked rookeries against grey skies, but sun-drenched Zeus standing tall upon the snow-capped peaks of Olympus and hurling thunderbolts and lightning shafts at the Titan armies or, when my conceits were less charitable, at the head of my mathematical tormentor.

Life at an English public school in the mid-thirties was no easy option, but not all my masters were as out of sympathy with me as that despot, and I was indebted to that establishment. Within its walls my love affair with Greece began and I yearned to visit those golden isles from whence sprang the epic magic of Homer's Odyssey and Hesiod's Theogony, that poem of the 8th century BC, explicitly featuring the exploits of the good, bad, brave and randy of the Greek pantheon – a work which assuredly would have sent a Lord Longford of the period a-reaching for his sal volatile; but I was to be denied the joy of that journey for many years. The drum beats of war rolled across Europe, Hitler put out the lights of London and Paris, Crete was invaded, the names of the first casualties suffered by the school were read out – those of boys three terms ahead of me – and I experienced my first vicarious brush with death. Naively believing that aerial combat would be more remote and chivalrous than trench warfare, and having after many hours of prayer and soul searching convinced myself that I had not the strength to 'turn the other cheek', regardless of the rights and wrongs of the argument, as Christ commanded, I joined the Royal Air Force.

I was convinced that I should not survive Armageddon. Two days before I left home to begin my long training as a fighter pilot, I read a valedictory sonnet by one who died in the first World War and was buried in an olive grove on the Isle of Skyros in the Sporades: Rupert Brooke's 'The Soldier'.

If I should die, think only this of me:
That there's some corner of a foreign field
That is for ever England. There shall be
In that rich earth a richer dust concealed;
A dust whom England bore, shaped, made aware,
Gave once her flowers to love, her ways to roam,
A body of England's breathing English air,
Washed by the rivers, blest by suns of home.

And think, this heart, all evil shed away,
A pulse in the eternal mind, no less
Gives somewhere back the thoughts by England
 given;
Her sights and sounds; dreams happy as her day;
And laughter, learnt of friends; and gentleness,
In hearts at peace, under an English heaven.[1]

I drew some consolation from it. And set off to learn to fight in the air.

Through a Glass Darkly

I do not like Saint Paul. He watched people throwing stones at Steven and then he made ladies wear hats in church and told them they must be nice to their husbands when they got home and shut up when they were talking. He said husbands were always right. I think he was horrid.

From an essay of a little girl aged 8

IT COULD BE ARGUED THAT that extract presented a good case against the ordination of women. However, it is only fair to relate that the same budding feminist advised her RI teacher that Salome was a lady who took her clothes off and danced naked in front of Harrods.

My late mother would have been sympathetic to her views. She, too, was no admirer of the saint who, she advanced on more than one occasion, was a sexist and intolerant to boot, an appreciation in which she was not alone among church-going women of her age who also designated him as a chauvinist pig. I do not endorse these views; although, because of my love for the Cretan people, I regret that he promoted the opinion of a second-rate Cretan prophet that all his

countrymen were 'liars, evil and beastly, lazy and greedy'. But I had the good fortune to be enlightened greatly about the character of Saint Paul – in Corinth.

In the Summer of 1975, and in the company of an Anglican ex-Eton chaplain, a splendid Christian gentleman seldom seen without a glass in his hand and his free arm around a woman's waist, I boarded the SS Uganda of Falklands fame as the guest speaker to a minority of cabin passengers and a consortium of preparatory schools who had booked the vessel for the purpose of broadening the horizons of their privileged charges and instructing them in the ways of the ancient races of the Mediterranean.

Together with my dog-collared friend I disembarked at the Athenian port of Piraeus and travelled by bus to Corinth. It was a hot and dusty journey made even more tedious by a wholly inaccurate and précised account of Saint Paul's missionary work in the area delivered by the driver's mate in fractured English, which crackled to us through an erratic hand-held microphone. Mercifully after a while the narrator extraordinaire gave up the unequal struggle and played a tape of bouzouki music until we reached journey's end. On arrival we watched the more elderly of our company make bee-lines for a sign spelled 'TOOLETE' written in crazed capitals on the wall of a roadside tourist cafeneon in front of which we had debussed, declined the glass of ouzo included in the price of the excursion, and disengaged ourselves from the coach-load. Ten minutes later, under a cloudless blue sky and from a mountain, tan-coloured like a lion's skin, we looked down on the ancient site of the Corinth of Saint Paul. In his time it was a young, brash, commercial city packed with Romans,

Greeks, Jews and Syrians, all attracted to a metropolis with no tradition save that of making money and possessed of every conceivable vice under the Grecian sun. But until that day I had been ignorant of the word 'corinthianise' which had been coined to describe an evil life. This I learned from my companion.

He was a fine Pauline scholar and taught me much that morning. It was he who turned Saint Paul into flesh and blood and made him come alive for me. It was thanks to him that I saw Paul through new eyes, not as the saint, but as the uncanonised, middle-aged, hook-nosed, hairy little Jewish widower with a twitch who, with Athenian mocking still in his ears and the marks of Philippian rods still on his back, limped bow-legged into that moral sewer and stayed for eighteen months preaching the Gospel of Christ. And I listened intently as he unfolded the story.

'My God,' I said, not as a blasphemy but as a prayer, 'he did have guts, didn't he?' 'Oh, yes,' said my friend, 'he was tough all right. He must have been to have kept going in that cesspool – and afterwards. And don't forget,' he added, 'he was damned ill at the time, which wasn't really surprising.' He laughed quietly and rummaged in his pockets for his pipe and pouch. 'After all,' he said, 'he'd been through the mill when you think about it. I mean,' he continued as he filled the bowl, 'I doubt if either of us could take – what was it? – one stoning, three beatings by the Romans, five scourgings by the Jews, and most of those on an empty stomach, and still come up smiling.'

He looked at me quizzically. 'Ever thought what a Jewish scourging was like?' I shook my head. 'Well,' he said, 'I'll

tell you, Very briefly you were tied to a column by your hands, stripped to the waist and then, with a two-thonged scourge made of four strands of calf skin and two of ass's, you were beaten with all the force of the striker, thirteen times across the breast, thirteen times on the left shoulder, and thirteen upon the right. And that makes thirty nine strokes in all, doesn't it?' I winced as my imagination took over. 'Oh yes,' he said, 'he had guts all right. *And* he was ship-wrecked three times, remember; and chucked into prison more than once. In fact,' he went on, 'now I come to think of it, he'd have made a splendid scrum-half, that is if he could have seen the ball. He had dreadful ophthalmia, you know.'

As I have hinted, and as old Etonians would testify, my friend was no ordinary dyed-in-the-wool clergyman. He paused to light his pipe. 'But you know,' he continued, applying the flame and tamping the tobacco down with his forefinger between puffs, 'what really makes me admire the chap isn't so much his physical courage but his moral strength, his belief in his faith and his ability to bounce back and never give in in adversity. I tell you, for my money he was one of the greatest of the Apostles.'

He struck another match and re-ignited the stubborn tobacco. 'For instance,' he postulated, repeating the kindling, 'just suppose, for the sake of argument, that you spent a year and a half working all the hours that God gave you, devoting yourself – and against an active opposition – to building up an institution, or society, or business in which you believed more deeply than anything else, and despite all the odds *succeeded*, you'd be pretty chuffed, wouldn't you?' I nodded. 'Yes,' I said, 'I would.' 'But then suppose', he advanced,

pursuing the analogy, 'that within a very short while of leaving this flourishing establishment you heard that it had gone to pot, that everything for which you'd worked had been in vain, what would your reaction be?'

I shrugged my shoulders. 'Hard to say', I admitted. 'Disillusionment perhaps? Despair? Anger?' 'Exactly,' he said; and stabbed the air with his pipe stem. 'And mine. But that's what happened here after Paul left. And in less than three years the whole community went to the dogs. Oh yes. In-fighting among the priests, sodomy, rape, incest – the lot. And *that*', he emphasised, 'was the news which Paul had to stomach when it reached him in Ephesus; and he was having a pretty thin time of it there, don't forget. He must have been shattered by what he learned. But *his* reaction was the opposite of what ours would have been. For a start he didn't say, "Oh to hell with it!" or words to that effect and pronounce himself a failure. Nor did he fly into a rage and write a stinker to the Corinthians denouncing them. Instead, he sat down and wrote what I think is one of the most moving passages of all time.' He glanced toward me, questioningly. 'Remember it?' I nodded. 'Um,' I said, 'the one about faith, hope and charity?' 'That's it,' he said, 'and the greatest of these is charity. Or, as the New English Bible has it, "love".'

For half a minute or so he remained silent, quietly pulling at his pipe. Then: 'What a pity', he said, 'that most of the world seems to have forgotten that.' And he slapped me on the shoulder and smiled. 'Here endeth the first lesson', he said.

I went to bed early that night. And in the quiet of my cabin, with the sound of the sea slip-slopping against the Uganda's hull as we steamed toward Alexandria, I read the whole of

Saint Paul's first epistle to the Corinthians; and before I went to sleep I re-read J. B. Phillips' translation of the thirteenth chapter.

If I speak with the eloquence of men and of angels, but have no love, I become no more than blaring brass or crashing cymbal. If I have the gift of foretelling the future and hold in my mind not only all human knowledge but the very secrets of God, and if I also have that absolute faith which can move mountains, but have no love, I amount to nothing at all. If I dispose of all that I possess, yes, even if I give my own body to be burned, but have no love, I achieve precisely nothing.

The love of which I speak is slow to lose patience – it looks for a way of being constructive. It is not possessive; it is neither anxious to impress nor does it cherish inflated ideas of its own importance.

Love has good manners and does not pursue selfish advantage. It is not touchy. It does not keep account of evil or gloat over the wickedness of other people. On the contrary, it is glad with all good men when truth prevails.

Love knows no limit to its endurance, no end to its trust, no fading of its hope; it can outlast anything. It is, in fact, the one thing that still stands when all else is fallen.

For if there are prophecies they will be fulfilled and done with, if there are 'tongues' the need for them will disappear, if there is knowledge it will be swallowed up in truth. For our knowledge is always incomplete and

our prophecy is always incomplete, and when the complete comes, that is the end of the incomplete.

When I was a little child I talked and felt and thought like a little child. Now that I am a man my childish speech and feeling and thought have no further significance for me.

At present we are men looking at puzzling reflections in a mirror. The time will come when we shall see reality as a whole and face to face. At present all I know is a little fraction of the truth, but the time will come when I shall know it as fully as God now knows me!

In this life we have three great lasting qualities – faith, hope, and love. But the greatest of them is love.

The translation into modern prose may lose the poetry of the version on which I cut my scriptural teeth (and which I still prefer) but the power of the message is undiminished. For many it is made even clearer; and that is good. Love or charity, the choice of words is ours, *can* conquer all. As my clerical friend said: 'If *only* we'd give it a chance'; and he quoted from the Veda, the ancient Hindu Scripture:

Let us all protect one the other.
Let us all enjoy together.
Let us act valiantly together.
May spiritual knowledge ever shine before us.
Let us never *hate* one another.
And let Peace and Peace and Peace reign
 everywhere.

Love

At the present time when violence, clothed in life, dominates the world more cruelly than it ever has before, I still remain convinced that truth, *love*, peaceableness, meekness, and kindness are the *violence* that can master all other violence.[1]

Albert Schweitzer

SO WROTE THE PHILOSOPHER/SCIENTIST. And the voice of the clergy in the guise of William Temple endorsed the message:

> The greatest pleasure of life is love,
> The greatest treasure, contentment,
> The greatest possession, health,
> The greatest ease is sleep,
> The greatest medicine is a true friend.

Love, or as it is pronounced by legions of pop singers, 'lerve', may be a 'many splendoured thing' but it is probably the most misused word in the English language. When I was a boy I had my knuckles rapped, metaphorically speaking, for declaring that I loved treacle pudding. 'Boy,' rebuked my pedantic mentor, viewing me with disfavour, 'advance me

this. Would you smother a treacle pudding with *kisses*? Would you *embrace* a treacle pudding? Would you', said he, warming to his theme, '*marry* a treacle pudding?' I swallowed hard. 'No sir,' I said, 'gosh no.' 'Then pray, sir,' concluded my inquisitor, 'in future disabuse yourself of your adoration for this confection. Treacle pudding is inanimate and cannot be loved. It is *liked*.' Appositely my tutor's name was Fell. Moreover, he held a doctorate in English literature. I neither loved nor liked him and held dear the opinion of one Thomas Brown of the eighteenth century who, two hundred years before, had written epigrammatically of another of that name and distinction:

> I do not love you, Doctor Fell,
> But why I cannot tell.
> But this I know full well,
> I do not love you, Doctor Fell.[2]

Love, in the words of a lyric from *Iolanthe*, 'makes the world go round'; but some, like D. H. Lawrence, grew weary of the word and those who promoted it and moulded their lives upon it. 'I am sick', he wrote, at the conclusion of a verse entitled 'Elemental', 'of lovable people, somehow they are all a lie.' And in another poem he enlarged upon the argument:

> I am worn out
> With the effort of trying to love people
> and not succeeding.

Now I've made up my mind
I love nobody, I'm going to love nobody,
I'm not going to tell any lies about it
And it's final.

If there's a man here and there, or a woman
whom I can really like,
that's quite enough for me.

And if by a miracle a woman happened to come
 along
who warmed the cockles of my heart
I'd rejoice over the woman and warmed cockles of
 my heart
so long as it didn't all fizzle out in talk.[3]

Lawrence of Nottingham versus Paul of Tarsus – a jaundiced, acutely autobiographical poem, one of many which was, in a sense, an extract from the log-book of his own emotional experiences. Lawrence was intensely preoccupied with personal and not always happy relationships and many of his encounters with women left him scarred. But thankfully, most poets throughout the ages have written in praise of the overwhelming emotion of love. And from the medieval Latin of the tenth century comes one of the most beautiful love songs of all, 'Iam, Dulcis Amica'.

Iam, dulcis amica, venito,	Come, sweetheart, come
quam sicut cor meum diligo;	Dear as my heart to me,
Intra in cubiculum meum,	Come to the room
Ornamentis cunctis onustum.	I have made fine for thee.

Ibi sunt sedilia strata	Here there be couches spread,
et domus velis ornata,	Tapestry tented,
Floresque in domo sparguntur	Flowers for thee to tread,
herbeque fragrantes miscentur.	Green herbs sweet scented.
Est ibi mensa apposita	Here is the table spread
universis cibis onusta:	Love, to invite thee,
Ibi clarum vinum abundat	Clear is the wine and red,
et quidquid te, cara, delectat.	Love, to delight thee.
Ibi sonant dulces symphonie	Sweet sounds the viol,
inflantur et altius tibie;	Shriller the flute,
Ibi puer et docta puella	A lad and a maiden
pangunt tibi carmina bella:	Sing to the lute.
Hic cum plectro citharam tangit,	He'll touch the harp for thee
illa melos cum lira pangit;	She'll sing the air,
Portantque ministri pateras	They will bring wine for thee,
pigmentatis poculis plenas.	Choice wine and rare.
Non me iuvat tantum convivium	Yet for this care not I,
quantum post dulce colloquium	'Tis what comes after,
Nec rerum tantarum ubertas	Not all this lavishness,
ut dilecta familiaritas.	But thy dear laughter.
Iam nunc veni, soror electa	Mistress mine, come to me,
et pre cunctis mihi dilecta,	dearest of all,
Lux mee clara pupille	Light of mine eyes to me,
parsque maior anime mee.	Half of my soul.
Ego fui sola in silva	Alone in the wood
et dilexi loca secreta:	I have loved hidden places,
Frequenter effugi tumultum	Fled from the tumult,
et vitavi populum multum.	And crowding of faces.
Iam nix glaciesque liquescit,	Now the snow's melting,
Folium et herba virescit,	Out the leaves start,
Philomena iam cantat in alto,	The nightingale's singing,
Ardet amor cordis in antro.	Love's in the heart.
Karissima, noli tardare;	Dearest, delay not,

studeamus nos nunc amare,	Ours love to learn,
Sine te non potero vivere;	I live not without thee,
iam decet amorem perficere.	Love's hour is come.
Quid iuvat deferre, elcta,	What boots delay, Love,
que sunt tamen post facienda?	Since love must be?
Fac cito quod eris factura,	Make no more stay, Love,
in me non est aliqua mora.	I wait for thee.[4]

I well remember the first time I listened to that poem. It was read to me by an Italian actor in Florence and the mellowness of his tenor voice and the roundness of his vowels added extra music to the words and clad the Latin more melodiously than ever I heard in a classroom. It is a great piece of writing and undoubtedly the blueprint for Marlowe's sixteenth-century poem, 'The Passionate Shepherd to his Love' – one of the finest examples of Elizabethan pastoralism.

Come live with me and be my love,
And we will all the pleasures prove
That hills and valleys, dale and field,
And all the craggy mountains yield.

There will we sit upon the rocks
And see the shepherds feed their flocks,
By shallow rivers, to whose falls
Melodious birds sing madrigals.

There will I make thee beds of roses
And a thousand fragrant posies,
A cap of flowers, and a kirtle
Embroider'd all with leaves of myrtle.

A gown made of the finest wool,
Which from our pretty lambs we pull,

Fair-lined slippers for the cold
With buckles of the purest gold.

A belt of straw and ivy buds
With coral clasps and amber studs;
And if these pleasures may thee move
Come live with me and be my love.

The silver dishes for my meat
As precious as the gods do eat,
Shall on an ivory table be
Prepared each day for thee and me.

The shepherd swains shall dance and sing
For thy delight each May morning;
If these delights thy mind may move
Come live with me and be my love.[1]

I am very fond of that poem although as a boy I found some
of the suggested images a trifle unreal and distinctly un-
shepherd-like. 'Did', I asked myself 'shepherds of that period
really eat off silver dishes and ivory tables?' To reiterate, I
was rather young. But one of the best definitions of love, and
one of the most beautiful of sonnets ever to be written on the
subject, was by Shakespeare.

Let me not to the marriage of true minds
Admit impediments. Love is not love
Which alters when it alteration finds,
Or bends with the remover to remove:
O no! it is an ever-fixèd mark
That looks on tempests, and is never shaken;
It is the star to every wandering bark,

Whose worth's unknown, although his height is
 taken.
Love's not Time's fool, though rosy lips and cheeks
Within his bending sickle's compass come;
Love alters not with his brief hours and weeks
But bears it out ev'n to the edge of doom:
 If this be error, and upon me proved
 I never writ, nor no man ever loved.

An intellectual appreciation of love lauding the virtue of
constancy. No fervour, vehemence, ardour or passion within
those fourteen lines, merely an unqualified approbation of the
true qualities of love. I subscribe to them, but with my hand
on my heart I cannot say that I have always honoured the
criteria, hard though I have tried. On more than one occasion
I have been Time's fool; and my mind has frequently admitted
impediments. Too often in my youth I mistook passion for
love but discovered the difference in later years. Love, real
love, never dies; but passion ebbs as our sexual appetites
diminish and we become less erogenous. Perhaps that is why
old men (and women) can counsel more easily about the need
and ability to resist temptation. And perhaps that is why a
century after that of Shakespeare, Andrew Marvell, mindful
of the onrush of time, wrote an Ode to His Coy Mistress.

 Had we but world enough, and time,
 This coyness, Lady, were no crime.
 We would sit down and think which way
 To walk and pass our long love's day.
 Thou by the Indian Ganges' side
 Should'st rubies find; I by the tide

Of Humber would complain. I would
Love you ten years before the Flood,
And you should, if you please, refuse
Till the conversion of the Jews.
My vegetable love should grow
Vaster than empires, and more slow;
An hundred years should go to praise
Thine eyes and on thy forehead gaze;
Two hundred to adore each breast,
But thirty thousand to the rest;
An age at least to every part,
And the last age should show your heart.
For, Lady, you deserve this state,
Nor would I love at lower rate.

 But at my back I always hear
Time's wingèd chariot hurrying near;
And yonder all before us lie
Deserts of vast eternity.
Thy beauty shall no more be found,
Nor, in thy marble vault, shall sound
My echoing song; then worms shall try
That long preserved virginity,
And your quaint honour turn to dust,
And into ashes all my lust:
The grave's a fine and private place,
But none, I think, do there embrace.

 Now therefore, while the youthful hue
Sits on thy skin like morning dew,
And while thy willing soul transpires
At every pore with instant fires,

Now let us sport us while we may,
And now like amorous birds of prey,
Rather at once our time devour
Than languish in his slow-chapt power.
Let us roll all our strength and all
Our sweetness up into one ball,
And tear our pleasures with rough strife
Thorough the iron gates of life:
Thus, though we cannot make our sun
Stand still, yet we will make him run.

A poem for the young and the fire of youth – not one for those whose embers are growing cold as they grow old. Yet love lives on in those who have been one flesh, who have known the heady days of ecstasy when they too made the sun stand still but now lie looking back through the mists of time, dreaming of when they were young, and cushioned by contentment and secure in the bond of companionship, the harvest of a lifetime of love. With them, these Darbys and Joans, love takes on a new dimension. And their middle-aged children smile fondly and say, 'Really they're wonderful considering their age! Quite wrapped up in each other, aren't they? But it's hard to believe that they ever made love . . .'

Elizabeth Jennings wrote a poem on that subject. She dubbed it 'One Flesh'.

Lying apart now, each in a separate bed,
He with a book, keeping the light on late,
She like a girl dreaming of childhood,
All men elsewhere – it is as if they wait
Some new event: the book he holds unread,

Her eyes fixed on the ceiling overhead.

Tossed up like flotsam from a former passion,
How cool they lie. They hardly ever touch,
Or if they do it is like a confession
Of having little feeling – or too much.
Chastity faces them, a destination
For which their whole lives were a preparation.

Strangely apart, yet strangely close together,
Silence between them like a thread to hold
And not wind in. And time itself a feather
Touching them gently. Do they know they're old,
These two who are my father and my mother,
Whose fire from which I came, has now grown cold?

Oh! the comfort, the inexpressible comfort of feeling safe
with a person – having neither to weigh thoughts nor measure
words but pour them all out just as they are, chaff and grain
together, knowing that a faithful hand will sift them and with
a breath of kindness blow the chaff away.

Not my words but those of an American of the last century,
one Mrs Dinah Maria Mulock Craik, defining friendship in
a publication, *Poems That Touch the Heart*. She might well have
added, 'and never to suffer the pangs of loneliness', for
friendship and the love it engenders holds loneliness at bay.
To be lonely is to be friendless and that must be a dreadful
state to experience, especially for a child. That was made clear
with stark simplicity by a little girl aged seven, Susan
Desborough. I would have entitled her verse, '*Cri de Coeur*';
coldly she called it 'Loneliness'.

Let me play I beg you.
Go away we don't want you.
Oh please let me play
It's lonely with no friends
And I want to feel wanted.

They play nice games but I
Can't play – oh *please*.
No don't keep asking – we shan't let you play.
I can't play by myself.
Yes, you can you're only making things up, so go
 and play.

When I go home I hear them saying
What shall we do tonight?
We can play cowboys and we can have my tent
Oh what can we have to sit on
We can have my mummy's old rug
So when I go home I read a book.

The flip side of the love disc, the obverse of the coin of care.
And love is about caring, and involves friendship. To give
a definitive explanation of what friendship is, is no more easy
than it is to offer an absolute diagnosis of love with all its many
facets, but Kahlil Gibran has come closer than most. Of him,
George Russell wrote: 'I do not think the East has spoken
with so beautiful a voice since the Gitanjali of Rabindranath
Tagore.'

And a youth said, Speak to us of Friendship.
 And he answered, saying:
 Your friend is your needs answered.

He is your field which you sow with love and reap with thanksgiving.

And he is your board and your fireside.

For you come to him with your hunger, and you seek him for peace.

When your friend speaks his mind you fear not the 'nay' in your own mind, nor do you withold the 'ay'.

And when he is silent your heart ceases not to listen to his heart;

For without words, in friendship, all thoughts, all desires, all expectations are born and shared, with joy that is unacclaimed.

When you part from your friend, you grieve not;

For that which you love most in him may be clearer in his absence, as the mountain to the climber is clearer from the plain.

And let there be no purpose in friendship save the deepening of the spirit.

For love that seeks aught but the disclosure of its own mystery is not love but a net cast forth: and only the unprofitable is caught.

And let your best be for your friend.

If he must know the ebb of your tide, let him know its flood also.

For what is your friend that you should seek him with hours to kill!

Seek him always with hours to live.

For it is his to fill your need, but not your emptiness.

And in the sweetness of friendship let there be laughter, and the sharing of pleasures.

For in the dew of little things the heart finds its morning and is refreshed.

Passion, eroticism, care and friendship, four idioms in the vocabulary of love; but there is another word.

'*S'agapo*', said the Athenian to his girl friend, 'I love you' – a modern verb which has sprung from the Greek of the New Testament, *agapé*. Two thousand years ago that was used to specify the most mysterious and unfathomable of all love's qualities, the love which passes all understanding – the love of God.

War

HIGH FLIGHT

Oh I have slipped the surly bonds of earth
And danced the skies on laughter-silvered wings.
Sunward I've climbed, and joined the tumbling
 . mirth
Of sun-split clouds, and done a hundred things
You have not dreamed of – wheeled and soared
 and swung
High in the sunlit silence. Hov'ring there
I've chased the shouting wind along, and flung
My eager craft through footless hall of air.
Up, up the long, delirious, burning blue
I've topped the wind-swept heights with easy grace
Where never lark, nor even eagle, flew;
And while the silent, lifting wind I've trod
The high, untrespassed sanctity of space,
Put out my hand, and touched the face of God.[1]

PILOT OFFICER GILLESPIE MAGEE COMPOSED THAT VERSE in
1940. When he was killed he was still in his nineteenth year.

I can understand what motivated him to write those words. I, too, in my early twenties felt the exhilaration of unfettered flight and looked down upon the green and brown squares of an English landscape and saw toy cows and sheep grazing alongside silver ribboned rivers. I, too, can remember banking and lifting my craft high above the cotton-wool shrouds of cumulus and entering a blue and sunny world, alone in my very own kingdom, mesmerised by the sound of my Merlin engine and happy in Elysium. Such moments were magic but fleeting ones, mere mosaics in the broader canvas of war. My predominant memories are ones of fear. The sick, sinking sensation in the pit of my stomach prior to a scrambled take-off. Fear when I saw black crosses on the wings and fuselages of enemy planes; the smell of fear when I emptied my bowels inside my flying suit; the fear of sudden flames licking at my cockpit, and the fear of being shot at whilst dangling under the nylon umbrella of a parachute. But there was much on the credit side.

Had it not been for the war I should never have been fully aware of the utter obscenity of armed conflict; of the danger of unbridled nationalism, of the depths of moral degradation to which man can sink. Conversely, I would not have been evinced of the heights of self-sacrifice to which man may rise. And paramountly, how a temporary spell of blindness emphasises how much one takes for granted the gift of sight.

Unsighted for seventeen and a half days I indulged in an orgy of self-pity, and like Christ at Calvary cried out to God and asked why He had forsaken me. Never, I thought, would I see again the glory of a sunrise and sunset when the skies are shot with green and gold, or see ripened corn bending

under the wind at harvest home, or look upon the face of a beautiful woman. And in my veil of darkness, I wept.

Thanks to good nursing and the prayers of many – and despite what cynics may say I am a great believer in the efficacy of prayer – my sight returned; but my short period of blindness taught me a salutary lesson. During it I learned to differentiate between pity and compassion in a person's voice and, praise be, I was made aware of the true values of life. And when the red mists cleared and shadows gave way to sharpened images, like Saint John the Divine I saw a new heaven and a new earth. I began to *see* and not just look at the world around me. I saw the irridescence in a preening starling's wing, the coruscations on a dewdrop bejeweling a spider's web, the delicate traceries of frost on a window pane; and I looked at the night sky with fresh eyes and a new perception. And I recalled a prayer, long forgotten, which I heard as a child.

O God our Father and Lord of the sunshine and the starlight, we thank Thee for all Thy gifts. For the winter and the white beauty of the snow and frost; for the springtime with its dawn chorus of birds; for the long afternoons of summer when the roses bloom; for the falling leaves and ripened fruits of autumn and for the precious gift of sight. And when the city with its streets and office blocks hides us from the world of nature let the skies above the roofs remind us of Thine eternal beauty always present. And on days of dullness help us to keep the beauty of the roses in our minds and the song of the birds in our hearts. We ask these things through Jesus Christ our Lord. Amen.

The night sky and its wonders have always inspired writers both of poetry and fiction, and encouraged imagery. When Dante Gabriel Rossetti saw a young waxing moon he wrote: 'The curled moon was like a little feather fluttering far down the gulf.' And Gerard Manley Hopkins saw it 'thinned to the fringe of a fingernail held to a candle'. But as Charles Kingsley experienced, the darkness also brings a sense of peace and isolation.

> High among the lonely hills,
> While I lay beside my sheep
> Rest came down and filled my soul
> From the everlasting deep.
>
> Changeless march the stars above
> Changeless morn succeeds to even;
> Still the everlasting hills
> Changeless watch the changeless heaven . . .

I know how Kingsley felt. I too have savoured the feeling of perfect tranquillity, in the land where time is only an idea in the mind of God – Crete.

My first visit there was soon after the war when the wounds left by 'Man's inhumanity to Man' were still unhealed. I went to Souda and Maleme in the autumn to pay homage at the graves of my schoolfellows who had fallen in the Battle of Crete, and stayed for several days in the vicinity. I ate late one night in a taverna in an adjacent village, and when I had finished my meal and lingered over a glass of tsikouthia, a fiery transparent liquid made from a distillation of grape skins and stalks, which sends the blood a-racing through the veins,

I walked slowly, very slowly, back to my *pension*, supremely content with the world; but I did not go in directly. It was a lovely night and still warm, and so I stood leaning against a pillar, smoking a last pipe and listening to the high-pitched pip-pip-pipping of bats as they radared their ways through the dark under a sky pregnant with stars. The heavens were ablaze with them that night, sparkling like gems on jeweller's velvet and all so close, or so it seemed, that all I had to do was to stretch out my hand, pluck them from their setting one by one, put them in a bag and pay my way with them to Paradise. And, unashamed romantic that I am, as I gazed upward, lost in their beauty, I understood more perfectly the inspired words of Ptolomeus of Alexandria written centuries before. 'I know,' he wrote. 'I know well I am mortal, a feeble thing and fleeting; yet when I watch the wheelings of myriad star on star, my feet touch earth no longer. It is as if I were eating at the high God's own table, of Heaven's ambrosia.'

And so I stayed, happy and lost in the past and reading the mythologies of ancient Greece in the book of the sky. Gods and goddesses, heroes and heroines, all were there, their figures outlined in stars. At my back was the Plough of which Homer wrote, cutting its endless furrow around the Pole star and counterbalanced by the misshapen 'W' of Cassiopeia as she swung in her chair, doomed to circle the skies until the end of time, never rising, never setting. There was the Milky Way, that river of light from distant stars which men in years gone by saw as the burning cindered track of Phaeton's catastrophic ride in Apollo's chariot of the Sun; the Lyre of Orpheus with which he wooed Eurydice and played to Pluto in the Underworld, there it was, fixed to the sky with diamond

studded nails; and to the west the semi-circle of the Northern Crown, which Bacchus gave to Ariadne long ago on near-by Naxos, shone as a perpetual reminder of his love. I watched them until eventually thin cloud began to smudge the pictures, then, knocking out my pipe, I went indoors to bed. Man's conception of the universe, I reflected, had changed greatly since Achilles' shield was emblazoned with the stars of the Great Bear; but not so the beauty of the skies. That has remained constant, a rich heritage for us to cherish and take note – *if* we have a mind to.

That qualification is pertinent; too many of our fellows take their world for granted and, as I once did, 'look and do not see' – a thought which provoked Helen Keller, who was not only blind but deaf and dumb, to leave us with these thoughts:

We differ, blind and seeing, one from another, not in our senses, but in the use we make of them in imagination and courage with which we seek wisdom beyond our senses. It is more difficult to teach ignorance to think than to teach an intelligent blind man to see the grandeur of Niagara. I have walked with people whose eyes are full of light, but who see nothing in wood, sea or sky, nothing in the city streets, nothing in books. What a witless masquerade is this seeing! It were better far to sail for ever in the night of blindness, with sense and feeling and mind, than to be thus content with the mere act of seeing. They have the sunset, the morning skies, the purple of distant hills, yet their souls voyage through this enchanted world with a barren stare.[2]

The Joy of Living

Said the robin to the sparrow:
'I should really like to know
Why these anxious human beings
Rush about and worry so.'
Said the sparrow to the robin:
'Friend, I think that it must be
That they have no Heavenly Father
Such as cares for you and me.'

IT WAS VERY QUIET IN THE ROOM when she told me that the doctors had diagnosed cancer. 'It's my breast,' she said, 'but they think my liver may be affected too.' She paused. 'They were very kind', she said. There was a long silence broken only by the ticking of the clock and I felt cold as the news sank in. 'Oh God,' I said, 'oh God'; and we hugged one another and wept.

Thankfully my wife recovered but for the second time in my life a sharp shock made me aware of how precious life is. To transcribe the late Dr Johnson, the thought of execution concentrates the mind wonderfully. So it was with me, and I drank more deeply of every day as if it were my last, and looked more keenly at the world around me. I once heard

Evelyn Waugh say: 'When I was young almost everything was beautiful; now you have to hunt it out like a flea.' He was a tired, unwell man when he made that pronouncement and, I think, an embittered one; but he was wrong. Beauty stares us in the face if we take time to acknowledge it. Most of us do not. Often the excuse is that we are too busy and have little time to indulge in these luxuries, and mentally relax. Maybe that is so. Or is it because subconsciously we are afraid to grasp the moments of quiet reflection, short-lived though they may be. Television has all but destroyed the art of conversation, the transistor and the ear-plugged Walkman cocoon us in a compulsory cacophony, and we attempt to travel from A to B as if there was no tomorrow. As H. G. Wells observed many years ago:

> The activity to escape mental solitude is remarkable. Most of the rushing about in motor-cars is plainly due to that. The rich, ageing Americans in particular seem constantly in flight across the Atlantic from something that is always, nevertheless, waiting for them on the other side, whichever side it happens to be. There would not be all this vehement going to and fro if they were not afraid of something that sought them in the quiet places . . . There is only a little handful of water left now. What do you mean to do with it! What under the stars is the meaning of your life?[1]

I was favoured. At the time when I digested the possibility that my wife's life would be cut short, we lived in a village. It was not a setting of any great beauty but it had a certain tranquillity. In it I could walk unhurriedly across a street

undisciplined by traffic lights; smile at a stranger without
having my motives doubted; hear a blackbird sing its requiem
to a dying day, and watch a sky become pregnant with stars
instead of neon signs. And during the months of her
convalescence daily I took stock of my good fortune with an
added and deeper understanding.

Early one winter Sunday morning, shortly before the sun
had risen, while the last stars were clinging to the sky, I stood
outside our cottage. There, in the south-east, blazing with
all the fierceness of phosphorus, was Venus, white hot and
wonderful – 'My Hesperus, my morning and evening star
of love, my best and gentlest lady', as Longfellow called the
planet. Then, as it paled and the light grew stronger and I
walked to church through a landscape brittle and sparkling
with frost, I watched the sky become so full of gold and silver
that it seemed that the vault of heaven must have been quite
bankrupt. And I thought: 'Dear God! How dear life *is*! And
isn't it wonderful? – tomorrow's not even touched!'

So winter passed and the earth warmed. Sheep lambed,
spring danced in wearing the clean, unused colours of daffodil-
yellow and arabic white, cows drowned in buttercups, the
chaffinch and the chiffchaff called, and the dawn chorus, that
forty minutes of liquid exuberance, was heard again. Never
had I heard it sweeter. Nor had I looked more keenly upon
the summer roses, those blooms which Sappho of Lesbos called
the Queen of Flowers; nor in past Septembers had I watched
so avidly the swallows twittering and gathering for their mass
exodus back to Egypt.

It was in that autumn that my wife took a firmer grip on
life, but during those anxious months I had been shown what

it had to offer. In the words of the Battle Hymn of the
Republic, 'mine eyes *had* seen the glories of the Lord'; or,
to leave the sublime, like Noel Coward's Mrs Wentworth
Brewster, I had discovered in the nick of time that life was
meant for living. But it is strange that it sometimes takes the
thoughts of death, vicariously or at first hand, to make us
cognizant of that. Bernard Shaw let out that truth in the trial
scene in his *Saint Joan* when, threatened with the agonies of
the stake, the Maid recanted; owned that her 'voices' were
false, signed papers to that effect and awaited her promised
pardon and freedom. It was never given. Instead she heard
the sentence of perpetual imprisonment, and through all the
rhetoric of Shaw, Joan bared her heart and gave tongue:

Perpetual imprisonment! Am I not to be set free? . . .
Give me that writing. (*She rushes to the table; snatches up
the paper; and tears it into fragments.*) Light your fire; do
you think I dread it as much as the life of a rat in a hole?
My voices were right . . . They told me you were fools,
and that I must not listen to your fine words nor trust
to your charity. You promised me life; but you lied. You
think that life is nothing but not being dead. It is not
the bread and water that I fear; I can live on bread; when
have I asked for more? It is no hardship to drink water
if the water be clean. Bread has no sorrow for me and
water no affliction. But to shut me from the light of the
sky and the sight of the fields and the flowers; to chain
my feet so that I can never again ride with the soldiers
nor climb the hills; to make me breathe foul damp
darkness, and keep me from everything that brings me

back to the love of God . . . all this is worse than the furnace in the Bible that was heated seven times. I could do without my war horse; I could drag about in a skirt; I could let the banners and the trumpets and the knights and the soldiers pass me and leave me behind as they leave other women, if I only could still hear the wind in the trees, and the larks in the sunshine, the young lambs crying through the healthy frost, and the blessed church bells that send my angel voices floating to me on the wind. But without these things I cannot live . . .

Shaw's heroine reflected most of my listed values; but not all. The love of music was not in her inventory: it is in mine. For during these worried times I listened with fresh ears to the God-given genius of Beethoven, Bach, Handel and Haydn. But whilst I thrilled to the power and passion of Beethoven and to the grandeur of Handel, it was the sheer joy of Haydn's work which uplifted me most; and small wonder why.

When the poet Carpani asked Haydn how it happened that his church music was always so cheerful, the musician's reply was succinct. 'I cannot make it otherwise,' he said. 'I write according to the thoughts I feel. When I think upon God my heart is so full of joy that the notes dance and leap as it were from my pen. And since God has given me a cheerful heart it will be pardoned if I serve Him with a cheerful voice!'

Thank God for the men of joy! And for the Joy of Living! Amen.

Happiness and Laughter

I know a lad who lives in Heaven;
A seraph rascal, swift and light
And beautiful as a bird in flight
He is all laughter and joy and speed,
Flash a thought, and follows a deed.
There is no power on earth can bind
His dancing eye, his questing mind;
He greets creation with a nod,
And laughs into the face of God,
And God replies right comradely,
For sweet lads' laughter in Heaven must be;
And you have taught me, little son,
That God is joyous and full of fun.

W. R. Hughes

'WHAT', ASKED THE PLAINTIVE VOICE of a six-year-old coming
to me from hassock level during intercessions at Mattins,
'exactly are we supposed to be *doing* down here?' It was a good
question which made many a bended knee twitch, and I am
sure God laughed when He heard it. By the same token I am
certain He smiled when, in a different Surrey church in 1950,

the elderly incumbent in a moment of mental aberration invited us to pray not only for the Government of the day, but King John to boot. Shortly afterwards he was persuaded to take a long rest.

As a member of a family which over the ages has been equally divided between those taking Holy Orders in the Anglican Church and those giving orders in the armed services, I have inherited a rich anecdotal granary of gaffes, *bons mots* and enormities connected with the Church. Most are true but all have served to make me smile and to remind me that the Christian faith is about joy and happiness, traits which, alas, are not always manifest in the faces of many who embrace that religion. As someone wrote: 'There are few habits more common among Christians than of seeing and remembering unpleasant things.'

However, fortunately there are those who by example dispute that generalisation. One such person was an uncle of mine, a sometime Suffragan Bishop of York with twinkling eyes and a trenchant, puckish sense of humour. He once wrote to me from York where, during Holy Week, he had waited lunchless in the station for a train which never came. 'Minutes passed,' he wrote, 'the rumblings from my empty stomach echoed mournfully down the platform and in desperation I bought a pork pie from the buffet. It was', he concluded, 'older than I and twice as sad, and the eating of it the most severe Lenten penance I have ever experienced.'

There is an old tradition that a cup of gold is to be found wherever a rainbow touches the earth. And there are some people whose smile and whose voice seem, like a ray of

sunshine, to turn everything they touch into gold. Uncle Carey was of their number. His smile was magic and he carried with him the unforgettable aura of one who was in love with life; and God. He smiled – not with his teeth as some tend to do at the end of a cocktail party when, with voices vibrant with insincerity, and the enamel chipping off their incisors, they say, '*Lovely* to have had you darling, *do* come again' – but through his eyes, the windows of the soul as they have been called. It is of such men (and I use the word generically), many of whom, unlike Carey Knyvett, would be hard pressed to remember when they last went to church or chapel but who leave a room more warmed than when they enter it, that we say: 'I don't know what it is about that chap, but he does me good.' What we do not say, because in many echelons of British society the very mention of our Maker causes embarrassment, is: 'That man walks with God.' But the result of that alliance is what we see and feel. Nor should that be surprising. To walk with God spells happiness; and when we are happy we smile. And the act is catching. 'Laugh and the world laughs with you' is no empty axiom.

Carey Knyvett was an orthodox clergyman but, on his own admission, not a very good bishop. He was impatient of red tape and not infrequently caused his superiors to say, 'Tut! Tut!' or even worse. But he loved his fellows and wherever he went he left behind him the happiness of the gospel message. He laughed at life. In it he found much that was risible including a feature in *The West Indian*, a copy of which he sent me. It carried the banner: 'MAN BREAKS CHURCH BOX TO BUY RUM'. The man in question, an original criminal

by any standards, pleaded guilty to stealing one dollar and forty-five cents from a poor box in the township of Sauteurs, and gave the following explanation for his action.

Your Lordship, I had been a Roman Catholic for many years. Owing to I having joined Religion recently, I was sent to St Vincent on a course, where I pursued Bible History. I no sooner, on my return, realised that the Roman Catholic Church has the right doctrine, and therefore I returned to my original Faith. I then sought to receive my instructions from one of the youngest Priests, one Rev. Dr Taylor of Sauteurs, a splendid damn fellow. I set out on my mission on Sunday amidst showers of rain for Sauteurs. I found no etiquette from the people there, and moreover I knew no one there. On my arrival without having the opportunity to see the Father, and having travelling around, I grew tired and hungry, and sought a rest at the R. C. Church. It was on that occasion that I broke the Box and took the $1.45 to appease my hunger and thirst. I was wrong, but what operated in my mind at the time, was the second chapter of SAMUEL, in view of that fact that I was seeking enlightenment on the Scriptural matter, that was what I did.

Carey wrote: 'If you are not as familiar with the second chapter of the first book of Samuel as that gentleman was, the sixteenth verse reads: ". . . and then taketh as much as thy soul desireth; then he would answer him, Nay; but thou shalt give it to me now: and if not, I will take it by force".'

'You see, my dear John,' Carey added in a postscript, 'how

perceptive Shakespeare was – the Devil *can* cite Scripture for his purpose.' He also commended me to another article in the same publication which, he vowed, was the greatest piece of newspaper advertising of all times and not wholly divorced from religious overtones and piety in its undoubted catholicity. It began:

Greeting to Dear Friends – Our usual Xmas gift is once more open to you. Caskets of all classes A. B. and C. can be obtained at reasonable prices from the Anglo-American Funeral Agency, 75 Melville Street, St. George's and not to mention the influx of ornaments and Tombstones to be laid at the grave of your departed ones. Also specialise in Embalming and all classes of caskets. Canadian and American Designs also Monuments and statues.

We now take this opportunity to loan one free Coffin to any relative of the departed ones buried by Anglo-American Funeral Agency Co. Bills must be presented of the departed ones buried by the above named Company not later than 6 a.m. on 25th December 1961. Also all Caskets purchased 20% discount will be given from 26th December 1961 to 31st December 1961. We are now in a position to offer new designs. Anyone purchasing one of the new design Caskets will be given One Case Whisky free. Don't be prejudiced you can purchase your Coffin before death, come in and select. We are at your service Day and Night. We also offer you Oak Caskets with glass face also Steel Casket for burying at sea. We can also supply Hymns for all

religions, who pay for them will have them; also Last
Rite Sets, canned juices and best Burgess Batteries for
Radios Flashlights and Satellite from U.S.A. Also pocket
Radio Batteries. We now take this opportunity to wish
everyone a Merry Christmas and a Brilliant 1962.

Oh God our help in Ages past

Our Hope for years to come.

Family Guest House can also be obtained within.

Thankfully Uncle Carey was not the only Christian to
radiate *bonhomie* and to dispense happiness through a smile.
Many others have followed his philosophy although the
majority have not been accoutred in cassocks. Bob, the
newspaper vendor at Baker Street station, was one who
unconsciously emulated him. He and I exchanged chit-chat
for twenty years as I bought my *Evening Standard* from him
and when we retired together on the same day we had one
or three beers to celebrate the occasion.

Bob was an overweight Eastender in his early seventies,
seedy, bronchitic and with a luminous Dong of a nose bearing
testimony to a lifetime of increasing the brewers' profits.
Occasionally he did lower his voice to a rasping bellow as he
plied his trade, but at all times his voice was pure rust and
he demonstrated a vast knowledge of Anglo-Saxon. No
sentence was devoid of at least one adjective, but he too spread
warmth, goodwill and humour to all and sundry and left his
mark on evening commuters as they returned, office-stained
and weary, to their Dunromins and Restawhiles in metroland.

'Gawd bless yer guv',' he would wheeze as a paper changed
hands, 'mind 'ow yer go then mate! An' for Gawd's sake cheer

up, it may never [adjectival] 'appen – even if it 'as! Haw!
Haw! Haw! Stanerd! Stan-erd! Read all abaht it, tho' Gawd
knows why! Seen the 'eadline, mate? Bloody politicians! I tell
yer, they'll 'ave a lot to answer for to 'Im, if they get up there.
Yer, I wouldn't be in their shoes mate, lotta [adjectival]
ponces! Still, yer gotta larf aintcher? Paper! Pap . . . – oh
Gawd me tubes!' and so on.

Bob did have a faith. 'Oh yer,' he said, the day he told
me that his forty-year-old son had died of cancer the previous
week, 'I think there's Someone up there an' that. But why
'e 'ad to take Jimmy . . . I dunno. I suppose 'e's gotta plan
an' that, but it don't 'arf 'it yer bloody 'ard at times. Know
watter min?' And he drew his mittened hand across his eyes.
'Still,' he said, reaching for a grubby handkerchief, 'no good
bloody moaning, is it? That don't do no good to no one, does
it? Paper! Late Extra! Paper! . . .'

Bob is missed at Baker Street. As one of the station staff
allowed, 'He may have been a boozy old sod, but he wasn't
half a tonic. Always laughing, old Bob was . . .'

Bob and I were good friends, and have remained so. Now
and again I visit him in his bedsit in Camberwell, and he still
makes me chuckle. Earthy he may be, but his heart is pure
gold and he continues to restore my faith in human nature
when it tends to wane, and laughter goes out of my life as
it does at times. So too did another who some years back came
into my commuting life on the Metropolitan Line – 'Jesus
Loves Me', a ticket collector of Northwick Park.

Northwick Park is the station which serves the denizens of
Kenton in North London and from where they are transported
– for the most part unwillingly – to Baker Street and, if

they have a mind to, further north to Kings Cross and far off Aldgate East. Daily awakened by digital alarm clocks – the cockerels of suburbia – they open sleep-encrusted eyes, break their fast with a bowl of All-bran and a cup of instant coffee, peck their wives perfunctorily upon their cheeks as their children are force-fed and dressed for school, and set off on the well tried trek to the station. There, ignoring one another by common consent and in the best traditions of all British travellers, silently they buy their Guardians, Telegraphs and Suns from the kiosk in the subway, aphasically present their 'seasons' at the barrier, and mutely wait for the train. But in the past all were greeted by Jesus Loves Me and grudgingly made to break their vows of silence.

Her real name was Beatrice but privately I always knew her as 'Jesus Loves Me' for that was what her lapel badge proclaimed in large black capitals. Not that she had need to advertise that fact. Morning and evening it was plainly obvious that she was sure He did, and equally patent that she loved Him. Large, black and comely in appearance, not unlike a beaming ebony Friar Tuck in drag, she was a shining bespectacled Trinidadian on whom the sun never failed to shine regardless of the state of the weather or time of day. 'Goodnight, my darlin',' she would call out as the evening passengers returned, 'God bless you Sir! That's right, my love, have a good supper an' put your feet up – mine are killin' me! Goodnight, goodnight.' And it was the same pattern in the morning. There she would be at the top of the stairs, standing by her glass-fronted cubicle with a welcome smile and, despite strong resistance from some, making us feel that the day augured well even though it was pouring with rain.

'Never mind, my dear,' she would say as the downpour increased, 'it's givin' de nice flowers a good drink, God love them!'

'Jesus Loves Me' never changed – not even when she received abuse when the trains were late. It may not have been her fault that they had been delayed but that made little difference. She was the first to feel the customer's wrath. 'Ah,' she said, as the disgruntled ones faded into the night nursing unpleasant thoughts about London Underground in particular and the transport system in general, 'they don' mean it, man. An' if it makes them feel better I don' mind. No! No! No! – I jus' turn de other cheek like de Good Book says and laugh to myself. Oh yes! I laugh like mad, like crazy man. In this job you've got to have a sense of humour otherwise you'd be cryin' all day long, and we don' wan' that, do we, love? – we've had enough wetness this year already!'

She was right of course, on both counts; but it is never easy to smile when one is hurt by words or physical pain. Pain is a great smile eraser; but Jesus Loves Me was a splendid example of what one can do if one really tries.

My day was emptier when she left Northwick Park six years ago to serve at another station, but wherever she is she will be lightening the darkness with her smile, her personality and manifestation of her faith, and brightening the lives of passengers. And at Northwick Park, although physically she is absent like the Jesus she adores and whose presence shines through her, I can still hear her laugh from the top of the stairs and am grateful for the legacy of love she had left behind. I doubt if the name of Thomas Dekker would be known to her, but I think she would approve of his thoughts, and words:

To awaken each morning with a smile brightening my face; to greet the day with reverence for the opportunities it contains; to approach my work with a clean mind; to hold ever before me, even in the doing of little things, the Ultimate Purpose toward which I am working; to meet men and women with laughter on my lips and love in my heart; to be gentle, kind, and courteous through all the hours; to approach the night with weariness that ever woos sleep, and the joy that comes from work well done – this is how I desire to waste wisely my days.

An exacting road to follow, but one worth attempting even if one becomes footsore *en route*. But a final word on laughter and smiles. Although tradition represents Jesus as a 'Man of Sorrows' bowed down and acquainted with grief, He is also a 'Man of Joys'; and acquainted with laughter.

Tender Loving Care

'There is more kindness in our wicked world than vice;
but much of it lies in hiding.'

I HAPPENED UPON THAT QUOTATION when the slip of paper
upon which it was written butterflied out of a book of verse
in which it had been doing duty as a marker. I have no idea
from where or from whom it originated, but there is much
truth in the observation. Contrary to opinions held in some
quarters, *homo sapiens* does display more benevolence than
meanness to his fellows, a fact of which I was made aware
in Greece.

I have never enjoyed a good sense of balance, nor, despite
my service in the RAF, had a head for heights. Rudely, those
deficiencies were confirmed four years ago in the Cretan village
of Paleochora where I was staying *en famille* with a nursing
sister friend of mine named Maria. In the wee small hours
of a late May morning, and with a crash which must have
been measurable on the Richter Scale and recorded in Turkey,
I fell backward down a flight of fourteen stone steps in the
pension, fractured my head on the paved courtyard and, as
it transpired, broke my back. It was a splendid production

number and one which, suitably embroidered in true Greek tradition, was to enter the annals of Paleochoran folklore.

Bleeding profusely from my scalp and accompanied by Maria and lamentations from our hosts I was escorted to the unsprung village ambulance and driven over an unmade, snaking mountain road to the general hospital in the distant township of Chania. It was a sobering experience; conditions in rural Greek hospitals have to be seen to be believed. However, once there and ensconced in a wheelchair designed to cater for a Macedonian dwarf, I was zig-zagged into the out-patients department, examined first by a cigarette-smoking nurse whose finger-nails matched the colour of her rolled-down black stockings, and then by a similarly addicted doctor with an ill-fitting hairpiece and very thick glasses. Both allowed ash from their half-smoked cigarettes to fall into my open wound before the latter, sighing deeply after a final inhalation, stitched up my head with the expertise of a novice crochet worker. He then offered me two aspirin as a panacea and suggested I returned to Paleochora. However, he continued, lighting a fresh cigarette from the stub of the other, if I were insured perhaps it would be advisable for me to go to Athens for a brain scan and thence back to London with all convenient speed. Hippocrates would not have been proud of him.

Two hours later as dawn was breaking, and feeling the onset of the effects of whiplash, I was laid carefully on my bed where I prayed for death. Next day I was stretchered back to Chania, flown feet first to Athens and then to hospital in England, but not before most of the village had filed past my bed, weeping. As Maria remarked later, it was not unlike the lying-in-state of the Pope.

'*Thenbirazi*,' choked little Yanni the pint-sized beer delivery man, producing a bottle of ouzo and kissing me on both cheeks, 'never mind – it could have been worse.' '*Ne*', said one-eyed Markos the cafeneon owner and Evangelina his wife presenting Maria with a ripe goat's-milk cheese and peering with prurient curiosity at my bandaged head, 'yes, much worse.' '*Symphono*,' chipped in Papa Stylianos, the local priest, giving me what in my dazed condition I assumed to be Extreme Unction, 'I agree. And take heart, my friend. I do not think God wishes you to have supper with Him just yet . . .'

Weeks after that trauma and when still restricted to a horizontal position in hospital, I read and re-read a message which Papa Stylianos had posted to me. It was a quotation from Socrates. 'Remember,' the philosopher wrote, 'no human condition is ever permanent; then you will not be overjoyed in good fortune, nor too sorrowful in misfortune.'

Despite the passing of time the memories of that Cretan drama are still fresh in my mind. But most poignant of all my recollections is not the discomfort which I suffered, but the goodness of very ordinary people. Of unshaven Nikos the part-time ambulance driver who, as we ricocheted from pothole to pothole to and from Chania, fed me with cigarettes and made small talk to distract me from the pain; of the deep felt concern of my hosts and the devotion of Maria who nursed me *en route* to England and saw me safely back; and of the extraordinary kindness and love afforded me by the unsophisticated village folk of Paleochora. All sharpened my awareness of how much selflessness there is in a world which sometimes appears uncaring. As the tag observes, 'There is

a lot of it about.' Nor did the caring stop. It came from hospital nurses, doctors and ward orderlies, and from physiotherapists who helped to restore my mobility in a hydrotherapy pool.

It was in its heated shallows that I was given further food for reflection.

I could sidle into the pool unaided: I still had power in my limbs, and control over them. Others, afflicted with osteoarthritis, had to be hoisted in mechanically. And while I awaited my turn to exercise, I watched the young come out of the water – nine- and thirteen-year-olds, some with the bodies of children half their age, but all with malformed limbs and the stunted movements of puppets. And as their mothers collected them and took them to the changing cubicles to help them dry and dress, I thought of my own children and grandchildren who are free from such physical disabilities. But above all, whenever I left the pool feeling despondent after a disappointing session, I reminded myself of a maxim which I once saw framed in a sampler. It read: 'I felt sorry because I had no shoes, until I met a man who had no feet'; and I learned afresh to count my blessings. But that was not the end of my benefits. I discovered another lesson.

Unable to attend my own church in Harrow-on-the-Hill, I was given Holy Communion in the kitchen-cum-dining room of my small flat by one Andrew, the Area Dean of Brent, a marvellously caring man of whom I am very fond. And in that room, and upon a polished pine refectory table backed by a shelf of similar wood, decorated with two brass candlesticks and an assortment of salt and pepper mills, Andrew placed a simple wooden cross, lit the candles; and blew out the match. And before that table, with the

background hum of the refrigerator, he and I, together with Maria of Paleochoran fame, made our Communion.

It was a moment I shall never forget. I have worshipped in some of the grandest cathedrals and churches in the country, but never, ever – and God alone knows – have I felt the presence of Jesus Christ so keenly as I did on that day in my kitchen. I am sure that cynics will have a ready answer for that; that, being physically under par I was susceptible to emotion. Be that as it may, my memory of that experience will never be rubbed out, no more than will the realisation that one does not need a high altar before which to kneel in order to celebrate Our Lord's last supper. And when Andrew and Maria had left and I stood for a while looking at the table with the cross now gone, I realised, too, that if we wish we can, if only briefly, remember that supper of 2000 years ago in an Upper Room at every one of our meal times and remind ourselves of what it meant. But I found it odd that, indirectly, it had taken a broken spine to bring that home to me. As someone once said: 'The Lord moves in mysterious ways . . .'

My God! Are You There?

A fire mist and a planet,
A crystal and a cell,
A jelly-fish and a saurian,
And caves where the cave-men dwell;
Then a sense of law and beauty,
And a face turned from the clod –
Some call it Evolution,
And others call it God.[1]

LIKE MOST PERFORMERS and I use that word advisedly to include anything from circus seals to the Primates of York and Canterbury – I keep a scrapbook of press cuttings which, from time to time, I open, not wholly as an ego excursion, but to appraise myself of the high and low lights in my career. I did so the other day and noted that on more than one occasion I have been described as: 'broadcaster, author, and Director of the London Planetarium'. The descriptions were correct; but it was the last appellation which often provoked misunderstanding. Rightly, it was deduced that I was an astronomer, but inaccurately assumed *per se*, that I was a scientist. I am not. I had no formal scientific education at all.

I read Classics and English, for there lay my forte. None the less, my marriage to the arts did not prevent me from having a long and lasting love affair with astronomy, but unlike some, that science has never soured my faith and belief in God. And in that respect my thoughts turn to the poet W. B. Yeats who had his boyhood faith shattered by the telescope and those who used it. He wrote:

> Seek then no learning from the starry men,
> Who follow with the optic glass
> The whirling ways of stars that pass.
> Seek then, and this is also sooth,
> No word of theirs. The cold star bane
> Has cloven and rent their hearts in twain
> And dead is all their human truth.

Ironically, that stanza comes from a poem entitled 'The Happy Shepherd'; but in the intervening years between its composition and the present day, a revolution occurred in the world of astronomy. Radio telescopes brought us whispers from the abyss of space as they detected galaxies hitherto far out of the range of optical instruments, our conception of the universe of stars was enlarged, and the ranks of the theologically uncertain were swollen. They made their presence felt. On a Sunday 'phone in' programme on the BBC's Radio 4 I was asked this question: 'How in a world of increasing technological advance, and particularly in the field of astronomy, can you believe in God?'

It is not often that I bridle my tongue but to my dying credit I did not instance Saint Augustine who, when asked by a disbeliever what God was doing before He made Heaven,

replied a little acidly that He was busy creating Hell for people who asked foolish questions.

It *was* a foolish question. Asinine because it assumed that the material can affect the spiritual. It cannot. It never has and it never will. What the material can, and does, do is to blunt our sense of the spiritual; but the spirit remains. And God is a spirit, and to quote: 'they that worship Him must worship Him in spirit and in truth.' *Ergo* one has the choice between taking a theistic stance or standing upon the platform of atheism. Patently, I support the former option, but I cannot prove scientifically the existence of God, and by the same token the existence of God cannot be disproved. It is, therefore, a question of belief. And on an astronomical and technological plane one can either embrace the concept that the universe in which we live is the result of a cosmic accident (and we have been given the luxury of several alternatives) or believe that it was created by an omnipotence, and for a purpose. Once again it is a question of belief. And in that respect the situation has not changed since the cosmologically ignorant days of Chaucer, and before.

Four hundred years ago – a mere grain of sand in the hourglass of time – men still clung to the notion of a geocentric or Earth-centred universe as postulated by Eudoxus and later modified by two other Greeks, Aristotle and Ptolemy. It was a cosy, easily explainable world, full of moral purpose, composed of a series of concentric, transparent spheres made of ether which fitted one upon the other like the skins of an onion. To each in turn was attached one of the heavenly bodies, and at the core of this system was the round but motionless Earth. Around it rotated the crystalline spheres,

all moving at different speeds, and all, save one, travelling in an anti-clockwise direction and taking their incumbents with them. But one sphere turned clockwise from east to west and, moreover, completed its cycle in twenty-four hours. This was the Prime Mover, the furthest sphere from Earth, and the most powerful. Indeed, so great was its influence, its 'inflowing', that its power was communicated to the other spheres below it. Consequently, although they were inching their several ways around the Earth from west to east, their general movement was from east to west. And in that ingenious yet ingenuous way our forebears accounted for the daily passages of the Moon, Sun, planets and stars across the sky.

Although basically Greek this cosmological onion was Christianised. God, flanked by Cherubim and Seraphim, dwelt on the Prime Mover, and from that empyrean throne He governed the skies and issued warnings to erring mankind. If anything untoward appeared in the heavens clearly it was a sign of God's wrath; constantly Man was being signalled that his enormities were not going unnoticed. If he sinned in a moderation it was accepted that when his time came he would travel upward. If not, he had a very disagreeable journey to the other side of the Earth, to what we know as Australia, but which they called Purgatory, and thence to the bowels of the planet to live in torment in the company of Lucifer. In brief, the medievals lived between Heaven and Hell in a comfortable parochial universe in which quite properly, according to their lights, they had been given pride of place. But the picture changed; and Man's ego took a beating.

In the sixteenth century, and contrary to the established theological and cosmological arguments of the day, a Polish Canon, one Copernicus, had the temerity to suggest that the Earth moved round the Sun, and not vice versa – a theory later ratified by Galileo. The rot had set in.

Now the truth is known. We are not the centre of creation. We are intelligent specks, living upon one planet which with eight others is moving around another dot in the cosmos – our Sun. And the Sun itself is just one star of thousands of millions which form our galaxy. And *that* galaxy is but one member of untold millions of other stellar empires which, like the one in which by chance or design we live, are cartwheeling their ways through the vastness of space. So . . . the picture has been transformed yet again. But it is the same unaltered universe. It is our concept of it which has changed.

Unquestionably, in future years the canvas will become even broader. As Man probes – and I would argue, by the grace of God – deeper and deeper into outer space, increasingly more of its secrets will be given up. Yet paradoxically the more Man learns, the more he will realise how little he knows. But the newly acquired knowledge should also bring about a greater realisation of God; and the more discoveries that are made, the more we should find out about Truth, the tenet of Christian faith. And when in time it is revealed that we are not the only intelligent beings to inhabit a planet in just one of many solar systems (and I believe it arrogant to suppose that we *are*, for, as a Greek philosopher observed, 'it seems absurd that in a large field only one stalk should grow and in an infinite space only one world exist'), even though the revelation will present theologians with a field day as they

debate if or no the beings are with or without original sin, we shall have more proof of the greatness of God the Creator. So, in a sense, and despite some views to the contrary, the march of technology and space exploration is not eroding Divine Authority, but adding to it. We are, in effect, measuring God's size.

The exploration of space is important, for the missions are concerned not only with the hunt for scientific truth, but also in the search for what is Man. For example: when Neil Armstrong, the first man to set foot upon the Moon, made his historic landing upon that geological museum a quarter of a million miles away from its parent planet, it was as though the whole of mankind had stepped on to its surface with him. He and the other astronauts represented all of us; and we learned something.

We were shown what a miracle Man is; but we saw also how small and fragile he is – in every sense. And there perhaps lies the danger: that by becoming technological giants we may be evolving into spiritual dwarfs. I do not believe that Man is at risk of over-reaching himself, but I do fear that he is in peril of discovering something that he cannot handle. In short, his intellectual progress has not been matched by his spiritual advance. Consequently, because of this failure there is a tendency to cry: 'Look what Man is doing! What need have we of God?'; to cast upon the dust heap of oblivion the words of the Creed, 'I believe in one God, the Father Almighty, Maker of Heaven and Earth and of all things visible and invisible' – including Man. Man, with his God-given gifts of sight, hearing and intelligence, and a superb planet on which to live. Agreed, the cynic will ridicule such assertions.

'A superb planet,' he will mock, '*superb*? What about famine, pestilence, bigotry and other allied manifestations of Man's inhumanity to Man? Show me, I pray, the evidence of God's omnipotence and beneficence!'

I have heard that argument often. It is as old as the cedars of Lebanon. But the answer is very simple. The sunset is no less real because it is blotted out by the smoke from the pyres of Man's iniquities; and muffled though it can be by the ugly sounds of conflict and terrorism, the voice of God still calls to us through the sound of the wind, the waves, bird song and the laughter of innocent children. Hourly the presence of God is about us; but if Man chooses to ignore it, there then lies the tragedy.

> What a piece of work is a man! How noble in reason! how infinite in faculty! in form, in moving, how express and admirable! in action how like an angel! in apprehension how like a god! The beauty of the world! the paragon of animals! And yet, to me, what is this quintessence of dust? Man delights not me . . .

One picture. One viewpoint: Hamlet's. But there is another, happier picture at which I look. If I did not I should cease to have faith in the ultimate redemption of mankind. It is the picture of which Martin Luther King dreamed until his mortal existence was snuffed out by a single bullet.

> I have a dream that one day men will rise up and come to see that they are made to live together as brothers. I still have a dream this morning that one day every Negro in this country, every coloured person in the world, will be judged on the basis of the content of his

111

character rather than the colour of his skin, and every man will respect the dignity and worth of human personality. I still have a dream today that one day brotherhood will be more than a few words at the end of a prayer, but rather the first order of business of every legislative agenda. I still have a dream today that one day war will come to an end, that men will beat their swords into ploughshares and their spears into pruning hooks, that nations will no longer rise up against nations, neither will they study war any more. I still have a dream today that one day the lamb and the lion will lie down together and every man will sit under his own vine and fig tree and none shall be afraid. I still have a dream today that one day every valley shall be exalted and every mountain and hill will be made low, the rough places will be made smooth and the crooked places straight, and the glory of the Lord shall be revealed, and all flesh shall see it together. I still have a dream that with this faith we will be able to adjourn the councils of despair and bring new light into the dark chambers of pessimism. With this faith we will be able to speed up the day when there will be peace on earth and goodwill toward men. It will be a glorious day, the morning stars will sing together, and the sons of God will shout for joy.

I believe they will – one day. But as one of our elder statesmen said: 'It is no good talking about the Brotherhood of Man without a belief in the Fatherhood of God.'

Simplicity

A Question of Age

'How old are you?' the adult said
Patting the bratling on the head.
The earnest youngster dodged the imminent
 squeeze,
Patted the adult back, and snapped out 'Please,
Do tell me just precisely what it is you mean;
My age? By birth certificate or by Binet seen?
We cannot with sophisticate intelligence engage
On conversation round this theme of age
When you refuse to make it crystal clear
If you mean Mental, Chronological, or Reading
 here.
Let us be certain, sir, if we must use a pedagogic
 term
We use it right, in manner scientific, *just*, and firm!'
Abashed the untaught adult turned and fled
And wished that ageless child, Methuselah – or
 even dead.[1]

I HAVE MET CHILDREN LIKE THAT *enfant terrible*. They come in the category of Gifted Children.

No country should be without a Gifted Child; or even two, and we are fortunate to have ours. Blessed with an intelligence quotient well beyond their years and an insatiable curiosity compared with which Kipling's Elephant Child would appear world-weary, those reaching adulthood and not forced by a comparatively stunted home technology to leave for more enterprising foreign fields, will do their Motherland proud. But they are a demanding, questing section of youth and not easily satisfied intellectually. I know. Regularly, once a year in early January, four hundred of these prodigiosities, together with their less gifted parents, assembled and awaited me in the Planetarium. And I, recovering from the excesses of the Christmas festivities, awaited them.

My preparations for the occasion never varied. On the night before Philippi, I took to my bed early, and on the morning of the engagement allowed myself the luxury of two minutes' silent prayer prior to confronting the sea of brilliance before me. Thus fortified physically and spiritually, I entered the console, took a deep breath, waited for silence; and threw the book at their Gifted Heads.

I pronounced on the theories of Newton and Einstein, propounded about pulsars and quasars and quarks; I held forth on black holes, gamma and X-rays, and enthused over nebulae, novae and neutrons. I filled their gifted lives with galaxies, gas, and galactic clusters, drenched them in light-years, took them to the planets, and then, as my adrenal glands cried 'Halt!' I awaited their gifted questions. Never once was

I kept in suspense, nor did I ever cease to be impressed by the depth and catholicity of the interrogation.

Did I, as an astronomer, believe in God, and if so why? Was Patrick Moore like that all the time? What did I think about astrology? And lastly, and invariably delivered in a tone of urgency, 'Where's the toilet?' But one child in particular stands out in my memory. She was six years old, and had a gap in her teeth.

'Excuse me,' she said, 'but why do you use a light-year when a parsec's so much simpler?' Unlovingly I looked at her. 'My goodness,' I said, 'so you know what a parsec is, do you?' 'Of course,' she said with more than a hint of impatience, 'it's 3.26 light-years. Isn't it?' Numbly I agreed with her. Next to her, her very ordinary mother smiled indulgently. 'I don't know where she gets it from,' she said, 'I'm sure I don't . . .'

Our relationship did not end with that encounter; it continued by post. A week later I received a letter from her written with the aplomb of a Senior Wrangler in which she expounded her theory on the origin of the universe, and inviting me to submit mine. She also enclosed an apposite verse:

> At moment X
> the universe began.
> It began at point X.
> Since then,
> through the Hole in a Nozzle,
> stars have spewed. An

Inexhaustible gush
populates the void forever.

The universe was there
before time ran.
A grain
Slipped in the glass:
The past began.
The Container
of the Stars expands;
the sand
of matter multiplies forever.

For zero radius
to a certain span,
the universe, a Large Lung
specked with stars,
inhales time
until, turgent, it can
hold no more,
and collapses. The
space breathes, and inhales again,
and breathes again: Forever.

I do not know the author of that poem, but imaginatively it represents a modern if complex opinion on the 'how-did-it-all-begin' syndrome. Nor do I know the fate of the child although I suspect that she has grown into an intellectual giant – like my Great Aunt Marjorie.

Great Aunt Marjorie, now deceased, like Merlin the Wizard with whom, if legend is to be believed, she shared several physical characteristics, came from the West but lived in Ilkley

where her late husband had taught in the grammar school. When I last saw her she was a frail *petite* figure in her nineties with a shrill, piping voice but still with immaculate diction and a rare turn of phrase. A Welsh woman by birth and possessed of a brilliant intellect and a caustic tongue capable of verbal laceration in three languages, she had collected Honours degrees as lesser mortals do match-box labels. And somewhere along her academic road between the universities of Wales, Oxford and the Sorbonne, she had also collected my great uncle. 'Not that I tried,' she shrilled as she accounted for her excursion into matrimony; 'to be round with you, I found him a nuisance. But he followed me from Oxford, pursued me from Heidelberg, and wore me down in the Louvre. And that', said she, 'was that.'

Sadly my Great Aunt shook her head. 'He had a fine brain,' she mused, 'but no ambition. Schoolmastering in Ilkley was the pinnacle, his life. Ilkley', cried my Great Aunt in a rising cadence and inspired by metaphor, 'was his Parnassus! But for me,' she concluded dramatically, momentarily transformed by Welsh emotion into a contralto, 'Ilkley has been my intellectual graveyard. I long', said she, going over the top, 'for Charon to row me across the Styx!'

Six months later her wish was granted. The ferryman called and bore her away to where I knew not; and nor did she. Theologically she was unsure, and uncertain of eternity. I once asked her how she viewed the prospect of eternal life. She pursed her lips, tilted her pointed nose to heaven, and deliberated. Eventually she broke her silence. 'I think', said she, 'that it depends entirely in which direction one is certain of going.' And she smiled, acidly.

Great Aunt Marjorie was not afraid of dying, but she did not believe in God or Holy Scripture, and particularly the Old Testament which she dismissed out of hand. However, she did allow that it made good reading and readily could understand why it was a best seller. Privately I think that under her intellectual cloak there was a longing for a simple faith upon which to latch, and subsequently to give her hope.

After she had died and I had taken possession of her books I came upon a biography of Keats in which was recorded a conversation between the poet and the painter, Joseph Severn, who was by his side when he died in Italy in 1821. Like Great Aunt Marjorie, John Keats had no fear of death, but neither had he faith or belief. Even when he knew his end was near he said to Severn: '. . . some malignant being must have power over us, over whom the Almighty has little or no influence. Yet you know, Severn, I cannot believe in your book – the Bible – but I feel the horrible want of some faith – some hope – something to rest on. There must be such a book . . .'

The passage was heavily underlined.

Having passed through the valley of doubt myself, I can feel for the great-aunts of this world. Intellectually they have an abundance of gifts yet lack so much. Perhaps if they could look at the world through less gnostic eyes they would find that for which they seek and which other more simple folk have found. Like the gardener in Anna de Barry's moving poem, 'The Apple Tree'.

Some folk as can afford
So I've heard say,
Set up a sort of cross
Right in the garden way
To mind 'em of the Lord.

But I, when I do see
Thik apple tree
An' stoopin' limb
All spread wi' moss,
I think of Him
And how He talks wi' me.

I think of God
And how He trod
That garden long ago;
He walked, I reckon, to and fro
And then sat down
Upon the groun'
Or some low limb
That suited Him
Such as you see
On many a tree,
And on thik very one
Where I at set o' sun
Do sit and talk wi' He.

And mornings too, I rise and come
An' sit down where the branch be low;

A bird do sing, a bee do hum,
The flowers in the border blow,
And all my heart's so glad and clear
As pools when mists do disappear:
As pools a-laughing in the light
When morning air is swep' an' bright,
As pools what's got all Heaven in sight
So's my heart's cheer
When He be near.

He never pushed the garden door,
He left no foot mark on the floor;
I never heard 'n stir nor tread
And yet His hand do bless my head,
And when 'tis time for work to start
I takes Him with me in my heart.

And when I die, pray God I see
At very last thik apple tree
An' stoopin' limb
And think of Him
And all He's been to me.

I first read these verses in 1971, in a broadcast *With Great Pleasure*. It was followed by a shoal of listeners' letters asking for copies of it. Since then I have re-read it many times for I find it one of the most beautiful, sensitive, and above all simple appreciations of the care, joy and creativity of God. But equally unsophisticated and powerful is an epic poem by a negro lawyer from the southern states of America. Sparingly, the author, James Weldon Johnson, called it 'The Creation'. That, too, busied the lines to the BBC after I had delivered it.

120

And God stepped out on space,
And He looked around and said:
I'm lonely –
I'll make me a world.

And as far as the eye of God could see
Darkness covered everything,
Blacker than a hundred midnights
Down in a cypress swamp.

Then God smiled,
And the light broke,
And the darkness rolled up on one side,
And the light stood shining on the other,
And God said: That's good!

Then God reached out and took the light in His
 hands,
And God rolled the light around in His hands,
Until He made the sun.
And He set that sun a-blazing in the heavens.
And the light that was left from making the sun
God gathered it up in a shining ball,
And flung it against the darkness,
Spangling the night with the moon and stars.
Then down between
The darkness and the light
He hurled the world.
And God said: That's good!

Then God Himself stepped down –
And the sun was on His right hand,
And the moon was on His left;

And the stars were clustered about His feet.
And God walked, and where He trod
His footsteps hollowed the valleys out
And bulged the mountains up.

Then He stopped, and looked, and saw
That the earth was hot and barren.
So God stepped over to the edge of the world,
And He spat out the seven seas –
He batted His eyes and the lightnings flashed –
He clapped His hands and the thunders rolled –
And the waters above the earth came down,
The cooling waters came down.

Then the green grass sprouted,
And the little red flowers blossomed,
The pine-tree pointed his finger to the sky,
And the oak tree spread out his arms,
The lakes cuddled down in the hollows of the
 ground,
And the rivers ran down to the sea.
And God smiled again,
And the rainbow appeared,
And curled itself around His shoulder.

Then God raised His arm, and then waved His
 hand
Over the sea and over the land,
And He said: Bring forth! Bring forth!
And quicker than God could drop His hand,
Fishes and fowls,

And beasts and birds
Swam the rivers and the seas,
Roamed the forests and the woods,
And split the air with their wings.
And God said: That's good!

Then God walked around,
And God looked around
On all that He had made.
He looked at His sun,
And He looked at His moon,
And He looked at His little stars.
He looked on His world
With all its living things,
And God said: I'm lonely still.

Then God sat down —
On the steep side of a hill where He could think,
By a deep wide river He sat down.
With His head in His hands
God thought and thought,
Till He thought: I'll make me a man!

Up from the bed of the river
God scooped the clay;
And by the bed of the river
He kneeled him down;
And there the great God Almighty,
Who lit the sun and fixed it in the sky,
Who flung the stars to the most far corners of the
 night,

Who rounded the earth in the middle of His
 hand –
This great God, like a mammy bending over His
 baby
Kneeled down in the dust,
Toiling over a lump of clay
Till He shaped it in His own image:

Then into it He blew the breath of life,
And man became a living soul.[2]

Origins

THE UNKNOWN FACTOR

I can accept, because I'm told it's true
And observation prompts me to agree,
That what I'm standing on so trustingly –
This solid earth, this globe on which I grew
Whose complex, multi-featured face I view
As home – is circling, spinning, endlessly
Around the sun. What's more, it logically
Can be perceived that other planets do
The same. But telescopes can't show who wrote
The music for this stately, stellar dance;
Nor find the wisdom that controls each note
And scored the moonlight that it might enhance
Our earth. What steers each cosmic boat
Through boundless space? The hand of God – or
 chance?[1]

HOW? WHEN? WHY? Questions about the origin of the universe
are not unique. Nor are some of the answers to the
conundrum: four hundred years ago, the then Archbishop of

Armagh, a saintly if somewhat eccentric cleric named Ussher, excelled himself. The universe, he proclaimed in a strong Irish brogue, came into being at precisely ten of the clock on 26th October, 4004 BC, a conclusion which he reached by adding up the ages of all his favourite patriarchs and then embarking upon some obscure mathematics with which only he was familiar. Moreover, nobody laughed – at least not to his face. What they did in private over a glass of poteen is open to conjecture. However, long after his Gaelic bones had been laid to rest in the Emerald Isle, in matters astronomical scientists were ridiculed openly, and especially by satirists. This was particularly so during the seventeenth century when the Royal Society and the doings of its members underwent some pretty savage attacks launched by those who considered their activities completely useless. Several plays of that period had a plot based on the satirisation of a 'virtuoso' and although that word meant an amateur natural philosopher and therefore covered all who seriously were interested in science, it soon acquired an overtone and came to mean someone who prized the useless for its own sake. And it was during that time when the Moon featured largely in popular thought, that Sir Nicholas Gimcrack, the virtuoso in Thomas Shadwell's play of that name, was asked: 'Do you believe the Moon is an Earth, as you told us?'

> Believe it! [says Sir Nicholas] Believe it! I *know* it! I shall shortly publish a Book of Geography for it. Why, 'tis as big as our Earth; I can see all the mountainous parts, and Vallies, and Seas, and Lakes in it; nay, the larger sort of Animals, as Elephants and Camels; but

PUBLICK Buildings and Ships very easily. I have seen several Battles fought there. They have great Guns, and have the use of Gun-powder. At land they fight with Elephants and Castles. I have seen them!

I enjoy, too, the nineteenth-century account of other inhabited worlds in Lewis Carroll's *Sylvie and Bruno Concluded*, when the character 'Mein Herr' who appears to be an extra-terrestrial visitor, although he does not admit to it, asks: 'What is the smallest world you would care to inhabit?', and then continues:

A scientific friend of mine, who has made several balloon-voyages, assures me he has visited a planet so small that he could walk right round it in twenty minutes! There had been a great battle, just before his visit, which had ended rather oddly: the vanquished army ran away at full speed and in a very few minutes found themselves face to face with the victorious army, who were marching home again, and who were so frightened at finding themselves between two armies, that they surrendered at once![2]

Pure 'Looking Glass'. However, and perhaps surprisingly to many of us today, belief in the plurality of worlds was almost universal in the early part of the eighteenth century, and the poets revelled in it. In *The Creation* Blackmore wrote:

All these illustrious worlds, and many more,
Which by the tube astronomers explore:
And millions which the glass can ne'er descry,
Lost in the wilds of vast immensity;

> Are suns, are centres, whose superior sway
> Planets of various magnitudes obey.[3]

And almost in tandem with this belief was an emphasis on the infinite extent of the universe of stars. Newtonian theory apart, as the 'tubes', or telescopes, looked further and further into the skies, it became more and more difficult to imagine that the universe *could* have a boundary.

'Where', queried a poet, 'ends this mighty building? Where begins the suburbs of Creation? Where, the wall whose battlements look o'er into the vale of non existence? Nothing's strange abode.' And it was toward 'Nothing's strange abode' that the Victorians, staunch believers in progress and the merits of Empire building and in many cases led away from religion by nineteenth-century science, turned their attention.

Astronomy, as a means of conquering the universe, was supported. But if and when such a conquest was made, what would be the outcome? Nothing short of Utopia, suggested the author of a work entitled *The Martyrdom of Man*. And in a passage remarkable for its resemblance to a latter-day party political address, he advised his readers that:

> Disease will be extirpated; the causes of decay will be removed; immortality will be invented. And then, the earth being small, mankind will migrate into space, and will cross the airless Saharas which separate planet from planet, and sun from sun. The earth will become a Holy Land which will be visited by pilgrims from all quarters of the universe. Finally, men will master the forces of Nature; they will become themselves architects of systems, manufacturers of worlds.

And had Mr Reade, who gave birth to those extravagant flights of fancy been alive today, he might well have penned the addendum: 'that is if they don't blow themselves into eternity in the process.' However, in contrast to the avant-garde Mr Reade who may or may not have wondered what the Almighty would have to say about the intrusion into His private domain, and pondering on the ideas of other fertile worlds orbiting around a myriad of suns, troubled theologians posed questions. Were these other planetary systems:

Formed when the world at first existence gain'd?
And to one final period all ordained?
Or, since wide space they independent fill,
Apart created, and creating still?
Do scriptures clear, the aw'd assent oppose?
They chiefly our original disclose.
Do they assert, are we in being came,
God ne'er was own'd by the Creators name?
Where then were Angels, older race to man?
Who fell seduc'd, perhaps, ere he began:
Do they assert prolific pow'r at rest
Shall in no future instance shine confest?[4]

So the satirists, scientists, believers and non-believers had their say; as they always will. As long as man looks into the heavens he will conjecture on the past, present and future of our planet and the stars against which it moves as they in turn, with the passing hours, inch their way across the sky to their setting places. Thomas Hardy was one such contemplative. And in *Far From the Madding Crowd* he left us one of the finest descriptive passages on star motions and the passage of time.

The sky was clear – remarkably clear – and the twinkling of all the stars seemed to be but throbs of the same body, timed by a common pulse. The North Star was directly in the wind's eye, and since evening the Bear had swung round it outwardly to the east, till he was now at an angle with the meridian. A difference in colour in the stars – oftener read of than seen in England – was really perceptible here. The kingly brilliance of Sirius pierced the eye with a steely glitter, and the star called Capella was yellow, Aldebaran and Betelgeuse shone with a fiery red. To persons standing alone on a hill during a clear midnight such as this, the roll of the Earth eastward is almost a palpable movement. The sensation may be caused by a panoramic glide of the stars past earthly objects which is perceptible in a few minutes of stillness, or by the better outlook on space that a hill affords, or by the winds or by the solitude; but whatever be its origin, the impression of riding along is vivid and abiding. The 'poetry of motion' is a phrase much in use, and to enjoy the epic form of that gratification it is necessary to stand on a hill at a small hour of the night, and, having first expanded with a sense of difference from the mass of civilised mankind, who are dreamwrapped and disregardful of all such proceedings at this time, long and quietly watch your stately progress through the stars. After such a nocturnal reconnoitre it is hard to get back to earth, and to believe that the consciousness of such majestic speeding is derived from a tiny, human frame.

A little girl once wrote to me: 'I don't think I shall ever

be able to be a real astronomer because I am rotten at arithmetic and geometry and things like that what I think are boring. Also I hate my teacher. But I do like looking.'

I cannot remember my exact reply but I did offer her consolation by saying that one does not have to be a scientist or a mathematician – many of whom are more involved with lecturing indoors on theory and less in observing in the open – to enjoy the night sky. And maybe it was that realisation which motivated Walt Whitman to write his poem, 'The Learned Astronomer'.

When I heard the learn'd astronomer,
When the proofs, the figures, were ranged in
 columns before me
When I was shown the charts and diagrams, to add,
 to divide and measure them,
When I sitting heard the astronomer where he
 lectured with much applause in the lecture
 room,
How soon unaccountable I became tired and sick,
Till rising and gliding out I wandered off by myself,
In the mystical moist night air, and from time to
 time,
Looked up in perfect silence at the stars.

Whitman was right. Nothing is more conducive to thought than the black canopy of night. One can think of the fact that the stars at which we gaze are those under which the tide of history has ebbed and flowed. Beneath them the Roman legions marched, and wise men walked to Bethlehem – everywhere you look you are privy to the past, for you are

seeing the stars not as they are but as they were when their light set out on a journey to reach our eyes. You can think of how, when, and why the first constellations were named, of the myths and legends surrounding them; of the fact that every bright star has a name of its own: Alcyone, Merope, Maia, Electra, Bellatrix, Deneb and Saiph – some from the Greek and some from the Arabic; that every star you can see, and the millions more that you cannot, is a sun – some bigger than our sun, some smaller, but all great globes of gas speeding through space in their courses. But above all, you can think of what we are in the general scheme of things, of our place in space. No, one cannot look at the sky without thinking – a feeling expressed by that gentlest of men, John Masefield, in his 'Lollington Downs'.

I could not sleep for thinking of the sky
The unending sky, with all its million suns
Which turn their planets everlastingly
In nothing, where the fire-haired comet runs.
If I could sail that nothing, I should cross
Silence and emptiness with dark stars passing;
Then, in the darkness, see a point of gloss
Burn to a glow, and glare and keep amassing,
And rage into a sun with wandering planets,
And drop behind; and then, as I proceed,
See his last light upon his last moon's granites
Die to a dark that would be night indeed;
Night where my soul might sail a million years
In nothing, not even Death, not even tears.
How did the nothing come, how did these fires,

These million-leagues of fires, first toss their hair,
Licking the moons from heaven in their ires,
Flinging them forth for them to wander there?
What was the Mind? Was it a mind which thought?
Or chance? or law? or conscious law? or power?
Or a vast balance by vast clashes wrought?
Or Time at trial with Matter for an hour?
Or is it all a body where the cells
Are living things supporting something strange,
Whose mighty heart the singing planet swells
As it shoulders nothing in unending change?
Is this green earth of many-peopled pain
Part of a life, a cell within a brain?

It may be so; but let the unknown be.
We on this earth, are servants of the sun:
Out of the sun comes all the quick in me,
His golden touch is life to everyone.
His power it is that makes us spin through space;
His youth is April and his manhood bread;
Beauty is but a looking on his face;
He clears the mind, he makes the roses red.
What he may be, who knows? But we are his;
We roll through nothing round him year by year,
The withering leaves upon a tree which is,
Each with his greed, his little power, his fear,
What we may be, who knows? But everyone
Is dust on dust a servant of the sun.

Poor Ussher! He must be turning in his grave!

Growing Old

Grow old along with me!
The best is yet to be,
The last of life, for which the first was made:
Our times are in his hand
Who saith, 'A while I planned,
Youth shows but half; trust God: see all, nor be
 afraid.'

Then, welcome each rebuff
That turns earth's smoothness rough,
Each sting that bids nor sit nor stand but go!
Be our joys three-parts pain!
Strive, and hold cheap the strain;
Learn, nor account the pang; dare, never grudge
 the throe!

Not on the vulgar mass
Called 'work', must sentence pass,
Things done, that took the eye and had the price;
O'er which, from level stand,
The low world laid its hand,
Found straightway to its mind, could value in a
 trice:

But all, the world's coarse thumb
And finger failed to plumb,
So passed in making up the main account;
All instincts immature,
All purposes unsure,
That weighed not as his work, yet swelled the man's
 amount:

Thoughts hardly to be packed
Into a narrow act,
Fancies that broke through language and escaped;
All I could never be,
All, men ignored in me,
This, I was worth to God, whose wheel the pitcher
 shaped.

So, take and use thy work:
Amend what flaws may lurk,
What strain o' the stuff, what warpings past the
 aim!
My times be in thy hand!
Perfect the cup as planned!
Let age approve of youth, and death complete the
 same![1]

 Robert Browning

'You are old, Father William,' the young man said,
 'And your hair has become very white;
And yet you incessantly stand on your head –
 Do you think, at your age, it is right?'

'In my youth', Father William replied to his son,
 'I feared it might injure the brain;
But, now that I'm perfectly sure I have none,
 Why I do it again and again.'

'You are old,' said the youth, 'as I mentioned
 before,
 And have grown most uncommonly fat;
Yet you turned a back-somersault in at the door –
 Pray, what is the reason of that?'

'In my youth', said the sage, as he shook his grey
 locks,
 'I kept all my limbs very supple
By the use of this ointment – one shilling a box –
 Allow me to sell you a couple?'

'You are old', said the youth, 'and your jaws are
 too weak
 For anything tougher than suet;
Yet you finished the goose, with the bones and the
 beak –
 Pray how did you manage to do it?'

'In my youth,' said his father, 'I took to the law,
 And argued each case with my wife;
And the muscular strength, which it gave to my
 jaw,
 Has lasted the rest of my life.'

'You are old,' said the youth, 'one would hardly
 suppose
 That your eye was as steady as ever;

Yet you balanced an eel on the end of your nose –
 What made you so awfully clever?'

'I have answered three questions, and that is
 enough,'
 Said his father; 'don't give yourself airs!
Do you think I can listen all day to such stuff?
 Be off, or I'll kick you down stairs!'

WHILST I CANNOT READILY BRING TO MIND any of my contemporaries or seniors who publicly stand on their heads or who can be seen balancing eels on their noses in an attempt to prolong the vigour of youth, it is true to say that as the ageing process takes place and we enter into what coyly has been called the evening of life, many of us do exhibit certain eccentricities. My Uncle Piers was one such person.

Known affectionately as Pipey because he was never seen without a comforting briar precariously held between his dentures, he was not of my blood but an inherited uncle by marriage. When I first made acquaintance with him he was in his mid-seventies, a stocky, pink-faced Devonian with deep blue, permanently surprised eyes, who went through life whistling softly and tunelessly through his teeth when under stress, and with the air of a man who vaguely knew where he was but was not quite sure why, and who felt that he should be somewhere else but could not remember where. Uncharitably, certain of his close relations suggested that his peculiarities were the result of his having fallen from a horse in Rhodesia in the early part of the century, and then landing

head first on his sub-standard solar topee. My own private thoughts were that his idiosyncrasies were immanent and had been manifest long before he mounted the animal; or that when young he had been piscie-led on his native Dartmoor and had never recovered from the experience. But whatever the causes it was unanimously agreed that, with the advance of old age, Pipey became more yonderly and his traits more marked.

Wherever he wandered, Pipey left his mark. In the Home Counties he caused consternation during a service of Holy Matrimony in the Parish Church of Guildford by lighting his pipe as the bride said 'she would'; in nearby Bramley he was long remembered by a minor Canon whose sherry he topped up with soda-water; and in London, when accosted by a lady of easy virtue in Curzon Street who, it must be assumed, was either down on her luck or a supreme optimist, he afforded her considerable food for thought by telling her to go away, adding agitatedly that he was a respectably married woman. Further afield he disturbed the serenity of Bath when he was observed backing hurriedly out of a ladies' lavatory in the Lansdown Hotel; in Exeter he was pursued from a similar establishment by a fellow Devonian requesting the immediate return of his overcoat and walking stick, and in Truro he incurred the wrath of a retired Colonel of the Duke of Cornwall's Light Infantry when that officer returned to his hotel bedroom to find a naked, soap-sudded Pipey lying in his bath and vigorously using his loofah. It is related that for a moment the two men stared at one another in silent disbelief. 'What the devil . . .' roared the Colonel as the horrid truth sank in. 'What the hell's goin' on?' 'Ha! Ha!' said Pipey,

and started to whistle. Then clambering from his bath and pausing only to drape himself in the Colonel's towels, and to bundle his own clothes together, he exited damply leaving a trail of wet patches behind him, and still whistling.

Uncle Piers was what is known as 'a character', and his friends never mocked him. 'Poor Pipey,' they said, 'he's getting old, that's his trouble'. But later, when he became a social embarrassment and physically inept, they were less considerate of thought. 'Ah,' they said, 'the old boy's lost his marbles – it'll be a good thing for him when he goes.'

Ageing has its problems, and old age often can be cruel; but it also has its compensations. With the passing of youth and the entry into middle age and beyond, comes a lessening of the fear of public opinion. 'To know what you prefer', wrote Robert Louis Stevenson, 'and not to say "Amen" to what the world tells you you ought to prefer, is to keep your soul alive.' Wise words of a far-seeing man. In youth we often take part in activities which we do not really enjoy, because of the fear of being thought odd to refuse; it matters hugely what people think of us. In adolescence we are persecuted by hidden anxieties because we dare not disclose them for fear of being laughed at. In youth we hold our cards close to our chest: age gives us the experience to deal with such traumas. But perhaps the greatest compensation of all is that it is just the fact that we have left our youth behind us that enables us, sometimes, to be of use to those who are *still* young. As a clergyman wrote in a charming book, *In a Country Parson's Shoes*: 'It is true that youth calls to youth, but it is quite as true that when passing through dark passages of doubt and fear it is to middle age and old age that youth turns – to

someone who has passed along that way, and come through safely.' He continued:

> Our Lord wants to see certain things in His followers, at each stage of their lives. What Jesus desires to see in childhood and youth, in middle age and in old age, we can best find out by looking at His life. It is true that Our Lord died while still a young man, but His was the perfect life that understood, and still understands (for He is the same yesterday and today and for ever) all our difficulties and all ages; never let us forget that. Our Master is perfect Man as well as perfect God, and there is no difficulty at any age – of soul or mind or body – that He does not entirely understand.'

God. Omnipresent; all caring; all understanding; all seeing. But what, I wonder, when mortality seems a light-year distant, does youth make of old age? What do they see as they look upon the elderly and infirm, 'sans teeth . . . sans everything'? Do they perceive them as ever having been young, or do they see just drained, shrunken shells, incapable of memories? That was the question asked in verse form by an elderly woman patient in hospital. The poem was found in her locker by a cleaner, after the old lady had died. She had called it, 'Cry From a Crabbit Old Woman'.

> What do you see nurses, what do you see?
> Of what are you thinking when looking at me?
> A crabbit old woman, not very wise
> Uncertain of habit, with far away eyes,

Who dribbles her food and makes no reply
When you say in a loud voice 'I do wish you'd try',
Who seems not to notice the things that you do
And forever is losing a stocking or shoe.
Who, unresisting or not, lets you do as you will
With bathing and feeding, the long day to fill.
Is that what you're thinking? Is that what you see?
Then open your eyes nurse, you are not looking at
 me.
I'll tell you who I am as I sit here so still,
As I use at your bidding, as I eat at your will,
I'm a small child of ten with a father and mother,
A young girl of sixteen with wings on her feet
Dreaming that soon now a lover she'll meet.
A bride soon at twenty, my heart gives a leap,
Remembering the vows that I promised to keep.
At twenty-five now I have young of my own
Who need me to build a secure, happy home.
A woman of thirty, my young now grown fast,
Bound to each other with ties that should last.
At forty, my young sons, now grown, will be gone
But my man stays beside me to see I don't mourn.
At fifty, once more babies play round my knee,
Again we know children, my loved one and me.
Dark days are upon me, my husband is dead,
I look to the future, I shudder with dread,
For my young are all busy rearing young of their
 own,
And I think of the years and the love that I've
 known.

I'm an old woman now and nature is cruel,
'Tis her jest to make old age look a fool.
The body it crumbles, grace and vigour depart,
There is now a stone where I once had a heart.
But inside this old carcase a young girl still dwells,
And now and again my battered heart swells,
I remember the joys, I remember the pain,
And I'm loving and living life all over again.
And I think of the years all too few – gone too
 fast –
And accept the stark fact that nothing will last.
So open your eyes nurses, open and see
Not a crabbit old woman, look closer – see me![2]

The process of growing old is as certain as death and our progress through time is marked on our faces as well as upon the dial of a clock. One only has to look into a mirror to see how the lines of longitude, and in some cases lassitude, have etched themselves indelibly on what were once smooth, uncluttered, untried surfaces. These rilles, trenches, and occasionally chasms, are, we are told sympathetically, character lines, evidence of how life has treated us and how we have responded to life.

A shrewd glance into the face of any mature man or woman will bear testimony to that. Lines of drudgery and discontent running from nostrils to the edges of down-turned mouths; frown lines ingrained across foreheads; incised lines of sadness and gladness, and the generous laughter lines which fan out from the perimeters of eyes like those on a mathematician's protractor, all are visible. And of all these facial furrows the

last are the best to look upon, and the most enviable. 'With mirth and laughter let old wrinkles come', said Gratiano in *The Merchant of Venice*, but then went on to philosophise:

> Nature hath framed strange fellows in her time:
> Some that will evermore peep through their eyes
> And laugh like parrots at a bagpiper;
> And others of such vinegar aspect
> That they'll not show their teeth in way of smile,
> Though Nestor swear the jest be laughable.

Shakespeare was a keen observer of his fellows' countenances. So too are women's beauticians; and with good reason. Other people's faces are their fortune. 'Lines and wrinkles', they cry, 'betray your age and switch off your man! So ladies, splatter your faces with mud packs and creams, saturate your pores with our sweet-smelling oils, cover your eyes with cucumber slices and you'll look young and beautiful – again!' Moreover, they imply, one's sex life will improve beyond one's wildest dreams. What they do not say is that despite these cosmetic treatments, which require their quarry to spend much of their time looking like the remains of a mayonnaised coleslaw, the mask eventually will crack and truth will be paraded before an astonished public. Our ageing faces are registers of our past attitudes to life and nothing can disguise that fact. We are what we are. Some of us continue to shrug off the cares of the world with a smile, while others grumble on the unfairness and inequalities of life and enjoy their misery to the full.

These are the professional malcontents who would, I

suspect, complain in paradise if given the chance. Unfortunately, here on earth, they tend to spread their gloom wherever they go and I often wonder what their reaction would be if they were told that grumbling was not only a bad habit but a real sin as it makes others unhappy. In my experience, very often it is those who have the least cause to complain who are in the forefront of those who do so – a viewpoint shared by many of the doctors and nurses in the hospital to which during the past two years it seemed that I had a season ticket, and where I saw examples for myself.

'Mustn't grumble dear', said an old lady as I passed the time of day with her by the bed which she had occupied for some weeks. 'They won't let me get up yet, but I've a lot to be thankful for. Oh, yes, dear, a lot to be grateful for. Mustn't grumble.'

She died within three days of that conversation, but I remembered her words, and remind myself of them when I have a gripe about my aches, pains and other privations which invade my three score years and five. And I think, too, of a prayer attributed to a seventeenth-century nun (although I find the language more of this century than that of Stuart times!)[2] which asks for the grace to follow the old lady's conduct of life.

Lord, Thou knowest better than I know myself that I am growing older and will some day be old. Keep me from the fatal habit of thinking I must say something on every subject and on every occasion. Release me from craving to straighten out everybody's affairs. Make me

thoughtful but not moody: helpful but not bossy. With my vast store of wisdom it seems a pity not to use it all, but Thou knowest Lord that I want a few friends at the end.

Keep my mind free from the recital of endless details; give me wings to get to the point. Seal my lips on my aches and pains. They are increasing, and love of rehearsing them is becoming sweeter as the years go by. I dare not ask for grace to enjoy the tales of others' pains, but help me to endure them with patience.

I dare not ask for improved memory, but for a growing humility and a lessening cocksureness when my memory seems to clash with the memories of others. Teach me the glorious lesson that occasionally I may be mistaken.

Keep me reasonably sweet; I do not want to be a Saint – some of them are so hard to live with – but a sour old person is one of the crowning works of the devil. Give me the ability to see good things in unexpected places, and talents in unexpected people. And give me, O Lord, the grace to tell them so. Amen.

So be it. Even though I doubt that it *was* written 300 years ago, it is still a good orison to offer as one strolls down the last miles of one's own particular road, and to the beginning of another life. And as we near our ultimate furlong it is then, according to G. K. Chesterton, that we enjoy the bliss of a Second Childhood, and with our ageing eyes see things grow new, as we grow old.

A SECOND CHILDHOOD

When all my days are ending
And I have no song to sing,
I think I shall not be too old
To stare at everything;
As I stared once at a nursery door
Or a tall tree and a swing.

Wherein God's ponderous mercy hangs
On all my sins and me,
Because He does not take away
The terror from the tree
And stones still shine along the road
That are and cannot be.

Men grow too old for love, my love,
Men grow too old for wine,
But I shall not grow too old to see
Unearthly daylight shine,
Changing my chamber's dust to snow
Till I doubt if it be mine.

Behold, the crowning mercies melt,
The first surprises stay;
And in my dross is dropped a gift
For which I dare not pray:
That a man grow used to grief and joy;
But not to night and day.

Men grow too old for love, my love,
Men grow too old for lies;

But I shall not grow too old to see
Enormous night arise,
A cloud that is larger than the world
And a monster made of eyes.

Nor am I worthy to unloose
The latchet of my shoe;
Or shake the dust from off my feet
Or the staff that bears me through
On ground that is too good to last,
Too solid to be true.

Men grow too old to woo, my love,
Men grow too old to wed;
But I shall not grow too old to see
Hung crazily overhead
Incredible rafters when I wake
And find I am not dead.

A thrill of thunder in my hair;
Though blackening clouds be plain,
Still I am stung and startled
By the first drop of the rain:
Romance and pride and passion pass
And these are what remain.

Strange crawling carpets of the grass,
Wide windows of the sky;
So in this perilous grace of God
With all my sins go I;
And things grow new though I grow old,
Though I grow old and die.[3]

Adieu – but not Goodbye

Remember me when I am gone away,
Gone far away into the silent land;
When you can no more hold me by the hand,
Nor I half turn to go yet turning stay.
Remember me when no more day by day
You tell me of our future that you planned:
Only remember me; you understand
It will be late to counsel then or pray.
Yet if you should forget me for a while
And afterwards remember, do not grieve:
For if the darkness and corruption leave
A vestige of the thoughts that once I had,
Better by far you should forget and smile
Than that you should remember and be sad.[1]

Christina Rossetti

FRIEND TO YOU I SAY

In all creation there are but a few abiding truths
and chief among them is the existence,
 the constant reality of eternal life
no time for doubts, no time for petty argument.

THIS is true, that we are for ever the ongoing spirit
in its quest for perfection
 not at any ordained time, place, speed
but gradually, wholly towards God.

We are happy, nay blissful, we who comprehend
 these truths.
Many need amazing time – in a sense you cannot
 understand yet –
but we are all moving, moving, moving onwards,
truly the 'river of life'
which transcends the death of the body,
 except that the body is *also* eternal.

<div style="text-align:right">Edmund Campion (Saint Edmund)</div>

'YOU KNOW,' SAID A GREAT FRIEND OF MINE in the literary world, smiling at me across the coffee cups in the Garrick Club and with the full knowledge that he had only a month or two to live, 'the trouble with people is that they get far too wrapped up with the morbid aspects of death instead of accepting and making preparations for it. And there is nothing prurient about that! After all,' he went on, 'if, for example, one knew that sooner or later, for one reason or another, we'd have to leave our present house and be obliged to live elsewhere, I doubt if many, if any of us would make a blind move. I mean, surely we'd show an interest in our new home first, wouldn't we? So why, for God's sake, should it be considered morbid to contemplate the change from this life to Everlasting Life.'

And he smiled again. 'And', he added, 'in the words of Peter Pan, "To die will be an awfully big adventure." '

That was the last time I saw him; and the publishing world is the poorer without him; but his wise words are still with me. He was a man with an enormously strong faith and a zest for life, and in a sense he reflected the thoughts of James Montgomery: ''Tis not the whole of life to live, nor all of death to die.'

Nigel Hollis's death was a great sadness; so is that of any friend or relation. As long as we live their deaths will hurt us, and understandably. Christ Himself wept at the grave of His friend, so why should not we feel pain? And bitterness. But if we as Christians believe and trust in Him we must have the knowledge that they are in His safe keeping, and the bitterness will pass. Just as we did when they were alive, we shall love and pray for them, and they in turn with Him, will be mindful of us and our needs. As an eminent Cardinal once asked: 'Shall they love us *less* because they now have power to love us *more*?'

A young lance corporal, Jeffrey Peter Cummings, killed by an IRA bomb in March, 1989, left an envelope addressed to his parents. It was, he had instructed, to be opened only in the event of his death. In it was found this poem:

> To all my loved ones,
> Do not stand at my grave and weep, I am not
> there, I do not sleep.
> I am a thousand winds that blow,
> I am the diamond glints on snow,
> I am the sunlight on ripened grain.

I am the gentle autumn rain,
When you awaken in the morning's hush
I am the uplifting rush
of quiet birds in circled flight,
I am the soft stars that shine at night,
Do not stand at my grave and cry,
I am not there. I did not die.

He signed the poem 'Anonymous', and added: 'Thank you for ever, always and a day.' Peter Levi, Professor of Poetry at Oxford University, said: 'It's a well written poem, but not a great poem.' Maybe not. Maybe it is not in the same class as verses written by Brooke, Owen, Sassoon and other war poets, but in less than a hundred words that young soldier epitomised a Christian's attitude to death.

'Death', as Dylan Thomas wrote, 'shall have no dominion.' Quite true: all will be one under the moon and sun. But death is not only a great leveller. Saint Paul's last enemy is also a rallying cry to the clan. A funeral, melancholy spectacle though it can be, brings together family members many of whom are never seen except on such occasions. From far and wide they come to pay their last respects to those they would be hard pushed to recognise in life, let alone death, so long is it since they met them. Then, with the obsequies over, they gather briefly to exchange news, views, sandwiches and sherry, and then depart once more into the far flung outposts of the family, until the next time. But 'wakes', as they are known to northerners, are not what they used to be in the good old days north of Watford Gap. Such was the opinion of a cadaverous looking Yorkshire

undertaker I met in a pub in the West Riding of that county.

'By gum,' said that worthy in monotonous tomb-hollowed tones, 'it were a right concern fer't folk in them days were a wake. By gow it were. They'd bring t'coffin out ut parlour and in tut road – lovely brass 'andles it 'ad an' all – and put on't bowler 'ats, and get 'em all mixed oop like. Oh aye,' he went on, 'they did that.'

He paused, enjoying the memory. 'D'ye know,' he said, 'Ah once saw a chap wi't wrong bowler 'at on. Ah did! And by 'eck it were right cutting 'is lugs off! Aye,' he said 'it were. And Ah thawt, Eeh! I thawt, if Ah wait long enough I might coom across t'fellow that's got *is* on. But I never did. No.'

Regretfully and lugubriously he sipped his beer. 'But all the same,' he continued reflectively, 'it were all very respectful like tha' knows – all luv'ly an' black an' that. And they'd start off at top of street and wander down, nice and slow like, an' everybody'd line oop as they passed their 'ouses and then get in't queue and follow 'em down to church. Oh aye; and parson would say what a fine lad 'e were and that sun 'ad shone out of his arse; an' after they'd all 'ad a bloody good cry about 'im, they'd get sat down at funeral tea and stuff themselves wi' 'am. Oh aye,' he concluded, noisily finishing his ale, 'it were a right good do, were a funeral. They may not 'ave thowt much about 'em when they were alive, but by gow they didn't 'alf make a fuss of 'em when they were dead. But', he said, peering mournfully into his empty glass, 'that's life. In't it?'

Indubitably wakes, or post-funeral receptions as they are known in more genteel circles, do have their benefits: there is comfort and security in numbers; but by Mediterranean

standards our way of mourning is remarkable for its restraint. Inculcated English reticence still obliges us to curb our surface emotions in public, however deep the hurt within us, and we bottle up our grief, often to our physical detriment. Not so the Greeks. When a Greek mourns he does so uninhibitedly, ostentatiously, and for a long while. At a Greek wake even the coffee is black. I know. I have attended one, or, to be precise, stumbled upon one.

It was well past midnight in a village in Rhodes that unexpectedly I happened upon the Greek way of death. The night was moonless and very dark, the air oppressive and still, and as I made my way falteringly up the steep, unlit street which led to my *pension*, sheet lightning played above the clouds and thunder rumbled in the distance.

It was at the top of the hill that I saw my first light. It was soft and glimmered from a doorway on the right. Then, as I walked toward it, other lights appeared from the opposite side of the road. They moved and flickered through the darkness and then went out, and as I drew nearer to them I heard the murmur of muted voices and began to see the shadowy shapes of women, each carrying a candle. They crossed quietly to the open doorway, and went in. By its entrance stood three lounge-suited sentinels with stiff white collars and wearing ties. I had never seen neckwear before in the village, not even in church on Sundays, and I stopped, halted by the incongruity of their appearance.

The three heads slowly turned toward me. '*Kalinichta*,' I said to the pinstriped gentleman nearest to me, 'Goodnight', and made to move on. Gravely he bowed in return and gestured solemnly toward the door. 'Won't you please come

154

in, sir,' he said in a low voice and in English, but with a marked Australian twang, 'there are still one or two seats.' I hesitated. 'Please,' he insisted, 'you will be most welcome', and ushered me in.

It was an interesting if Kafkaesque scene which greeted me. The four walls of the room, which was candlelit, were lined by two rows of hard-backed chairs occupied by sombrely clad men and women, and three small children. Two were sucking their thumbs and the third, a lollipop. The centre of the room was occupied by a middle-aged gentleman also attired in an out-moded single-breasted pinstripe, and wearing shiny black boots. I had often seen his like standing and smiling waxily at me through the windows of Moss Bros and, in days long gone, the Fifty Shilling Tailors. There was however one important difference between them. This gentleman was unsmiling, and lying down. He was very, very dead. At his head sat his widow, red-eyed and weeping quietly into a handkerchief and flanked by four other ladies similarly employed.

'Will you come this way, please, sir,' said my guide, and showed me to a vacant second row seat to the right of the door. I sat down. 'Coffee, sir?' he inquired; and eased his collar with his forefinger. I nodded affirmatively and automatically. 'Sweet or medium?' he asked hollowly. 'Bitter, please', I said; and mopped my forehead. The atmosphere was stifling.

My host returned. 'Did you know him in life, sir?' he asked, passing me a cup and nodding toward the guest of honour. I shook my head. 'Stephano', he said by way of introduction. 'He died last week. In Melbourne. On holiday.' He cleared his throat. 'Three thousand Australian dollars it cost to bring

155

him home embalmed,' he intoned, 'and our airfares,' he added, 'but he would not have wished to stay in Australia. Not permanently.' His voice dropped half an octave. 'Stephano will be buried tomorrow', he said. He cleared his throat again. 'Like a biscuit?' he asked.

The second mention of the deceased's name brought a fresh outburst of sobbing from his widow and provoked a chain reaction among the assembled. The child with the lollipop choked on the bon-bon and was led out by its parents, and two more mourners took their places, disturbing the air as they did so. The candle flames flickered and the shadows jumped on the whitewashed walls, and I sat sipping but not tasting my coffee and let the soft sounds of grief wash over me. Three-quarters of an hour later surreptitiously I glanced at my watch and prepared to make my exit.

'*Parakalo*', said the lady in a head shawl next to me when I handed her my cup and eased past her, 'thank you.' I stood for a moment at the foot of the body with my head bowed. I said a short prayer, crossed myself from right to left in the fashion of the Greek Orthodox Church and was conscious of the murmur of understanding as I did so. 'Ah,' lisped an unshaven, toothless old man, nudging his neighbour, 'you see? He knows our custom. He does it the proper way. Bravo!' '*Ne*,' said his companion, similarly edentate, 'I know, I have seen him do it in the church.'

I turned to the widow. 'May God bless and be with you,' I said. '*Episis*,' she said through her handkerchief, 'and you; and thank you for coming in.'

I broadcast an account of that night in a Radio 4 series which I called *Near Myths*. It enraged a woman from Droitwich

Spa (who it emerged had never been to Greece) who accused me of blasphemy and irreverence. Happily hers was a lone voice but I hastened to assure her that I had intended no disrespect to my Greek friends; that I had given a factual eye-witness account of what had taken place. But I do remember wondering as I left the house in a daze and confusion of thought, if the affair had been a dream and not reality.

Was it possible, I asked myself as I wandered home, that I, a total stranger, had been ushered as if into a cinema, to view the corpse of a man I had never met, and had prayed for the soul of someone I had never known. And had a widow really thanked me for 'coming in' to share her vigil? But the events had happened and I was glad that I had been privy to the scene for it had underlined what I already knew – the strength of family unity in the Greek Islands. The man who had loved his country and his village had been brought home, and relatives and friends abroad had made the journey with him. And there, in a humble roughcast room they had cosseted his widow and given her strength in her hour of need. Nor, I reflected, would she ever be alone. The dead would be buried, but she would be cherished; and those moments in particular she would never forget, the hours when she was made aware that others cared about her grief. The overt Greek style of mourning may seem *outré* to English eyes but in many ways it is more efficacious behind closed doors on which no callers knock, a pattern which all too frequently is still prevalent in our country. Often when a silence hangs over the house and mourners are at their most vulnerable and in want of support, they are left alone to grieve in solitude. This inattention is not born of indifference, but of English reserve,

a fear of causing possible embarrassment to the callers themselves by encouraging the sorrowing to open the floodgates of emotion, or, more simply, by a feeling of inadequacy.

'I just didn't know what to say' is the excuse I have often heard advanced for the reason a call had not been paid to a newly bereaved widow or widower. Yet only a simple 'sorry' or even a silent handshake would speak volumes. However few or poor the words or gestures of comfort, nothing is likely to increase a feeling of loneliness more than apparent neglect.

The next day, in company with most of the villagers and several nondescript dogs, I followed Stephano to his last resting place in the low, whitewashed walled graveyard next to a tiny twelfth-century chapel dedicated to Saint Anastasia and reached by a long cypress-lined avenue. It was, I thought, a perfect pathway to one's journey's end. Even without an objective it made a pleasant walk and I retraced my steps along it, but away from the chapel, that same evening when the air was filled with the trilling of cicadas as they stridulated between the cypress branches.

A very old lady, bent double with arthritis and dressed in widow's weeds, slowly and painfully punted herself in my direction with a gnarled stick of olive wood, her face toward the ground. She was holding a small bunch of flowers in her left hand and singing quietly to herself as she advanced, oblivious of my approach. I called out 'good evening' as I neared her, and she stopped. Two red-rimmed watery blue eyes, opaque with extreme age and set in a shrivelled face focused falteringly upon me. '*Kalos*,' she piped; and repeated the greeting.

The eyes wavered, turned uncertainly to the flowers and then back to me. 'Are they not beautiful?' she asked, as a child would do; and slowly raised them to my nose. Obligingly I sniffed at the posy. 'They are most beautiful', I said, 'and their perfume is lovely.' '*Ne,*' she said, 'it is a good smell. They are for my husband.' With difficulty she motioned toward the cemetery. 'He is asleep up there,' she said; 'by the wall.' For a moment she gazed unseeingly into the distance lost in a private world, then slowly turned to me again. 'Soon I shall sleep there too,' she said, 'quite soon, you understand.' She smiled wearily but happily. 'And that will be good,' she said, 'we shall be together again. With God.' She nodded reassuringly to herself. '*Ne,*' she repeated, 'with God.' Then, once again, the tired eyes peered at me. 'Do *you* believe in the God?' she asked. I nodded. 'Yes,' I said, 'I do.' 'And do you believe that we do not die, but sleep; and go to Him in heaven?' Again I nodded. 'Bravo,' she quavered, caressing my arm in the way of all old Greek women; and then fell silent. Then, slowly turning her head toward the sky, now growing oyster pink in the fading light, she smiled again. 'When I was a child my mother would say that every star shone with the soul of a man. That is where we go to when we leave our bodies – to the stars. *Ne,* that is what she said, "to the stars".' Again her eyes sought mine. 'And do you believe *that*?' she asked. '*Yati oche,*' I said, and patted her hand. 'Why not?' '*Ne*', she said approvingly, 'why not?' And bidding me goodbye she went on her way, singing reedily.

Her mother's folklore was by no means original. In one form or another I have heard it told from Tanzania to Tooting Bec. But it put me much in mind of a story originally written

by Dickens but later adapted by a lady called Mary Proctor who re-told it in the guise of a little girl telling it to an ailing, bed-ridden younger brother. Written for children in a book heavy with moral overtones and in true Victorian style, it is unashamedly sentimental, but even now when we know that the moon is not made of green cheese, it has a deal of charm and a tear-jerking capacity. It was called 'God Bless the Star'.

There was once a beautiful bright star that shone down upon the home of a little boy and girl who wondered at its light. They learned to know it so well that every evening the one who saw it first would say, 'I see the star', and before they went to sleep at night they would say 'Goodnight' to the star, and 'God bless the star!'

But the little girl, while she was still very young, became very weak and feeble, so that she was unable to go to the window and look at the star, so the brother would stand there alone and watch for it. As soon as he saw it he would turn round to his sister, and say, 'I see the star', and the little sister would answer gently, 'God bless my brother and the star!' One evening the brother looked at the star alone, for his little sister had passed away to her home among the stars. That was a sad and lonely evening for the brother, and at night he dreamed of his sister. Her face seemed to be looking at him from the bright star, and he could see a pathway of light reaching from it to his room.

Along the pathway were people passing from this earth to the stars. Angels waited to receive them, and as they reached the star people came out to welcome them.

Kissing their friends tenderly, they went away together down avenues of light. But there was one who waited patiently near the entrance of the star and asked the guide who led the people thither if her brother had not yet come.

'Not yet,' he replied kindly and as she turned sadly away the little brother reached out his arms toward her, and said, 'Here I am, sister; I am coming to you.'

As she turned her beaming eyes on him, the star was shining into the room, and he could see its rays of light through his tears. From that hour the child looked at that star as his future home, where he would some day meet his angel sister again.

And he waited, oh! so patiently, and the years rolled slowly by. He grew to manhood, and still the star shone down upon him at night. Then he grew to be an old man with gray hair and wrinkled face, and his steps were slow and feeble. Others had gone before him to the star. A little brother who died while he was young – his mother – his daughter – and now surely his own time had come.

One night he lay upon a bed of sickness, and as his children gathered around him he suddenly cried out, as he had long ago, 'I see the star!' Then they whispered to each other 'He is dying', and he heard them, and said: 'I am. My age is falling from me like a mantle and I move toward the star as a child. And, O my Father, now I thank thee that the star has so often opened to receive those dear ones who await me!'

161

And the next day the star was shining, and it still shines, upon his grave.[2]

I doubt if the style of Mary Proctor's story would have much appeal to the space-orientated modern child, but its message is still as valid as it was when the tale was listened to by the crinolined and sailor-suited middle-class children of her age, for whose ears it was intended. Death may be the final curtain on the last act of our mortal drama, but it is the beginning of a new and joyous one. So, in the words of Christina Rossetti:

> When I am dead my dearest
> Sing no sad songs for me.
> Plant thou no roses at my head
> Nor shady cypress tree;
> Be the green grass above me
> With showers and dewdrops wet
> And if thou wilt, remember,
> And if thou wilt, forget.
>
> I shall not see the shadows,
> I shall not feel the rain;
> I shall not hear the nightingale
> Sing on as if in pain:
> And dreaming through the twilight
> That doth not rise nor set
> Haply I may remember,
> And haply may forget.

One last word on this subject. It would be foolish to disguise the fact that the physical aspect of death can be frightening.

But the phobia can be beaten. The best way to overcome fear is to turn and face it, and, through prayer, to ask God for His help to deal with it. My bishop uncle told me of a practical, busy bee of a Yorkshire woman who despite her involvement with her own multifarious affairs, and it has to be said, other people's, daily would pray: 'Dear Lord! Help me in my busy life to prepare for my death; and help me to be content that it shall be when Thou wilt it, where Thou wilt it, and as Thou wilt it. And into Thy hands I commend my spirit, now and always.'

Even if one admits to the old adage that 'all men think all men mortal but themselves', to pray along those lines is no bad habit – if, of course, one can spare the time. But as Sir Jacob Ashley said before the battle of Edgehill in 1642: 'O Lord, even though Thou knowest how busy I must be this day, if I forget Thee, do not Thou forget me!'

Easter

THE DONKEY

When fishes flew and forests walked,
 And figs grew upon thorn,
Some moment when the moon was blood,
 Then surely I was born;

With monstrous head and sickening cry
 And ears like errant wings,
The devil's walking parody
 On all four-footed things.

The tattered outlaw of the earth,
 Of ancient crooked will;
Starve, scourge, deride me: I am dumb,
 I keep my secret still.

Fools! For I also had my hour;
 One far fierce hour and sweet;
There was a shout about my ears,
 And palms before my feet.

G. K. Chesterton

'AND WHAT', I ASKED MY DAUGHTER ANNE when she was in
her ninth year, 'are you going to give up for Lent?' There

165

was a long pause. Then: 'I think', she said, 'that I'm going to stop thinking nasty things about silly, fat, smelly old Shirley Prodnose.' Prodnose is not the correct name of my daughter's butt, but she was not an attractive child, and Anne's pledged self-imposed moral penance was a severe one. In Switzerland at a similar age, I elected to forgo my weekly ration of *langues de chat*, those thin, mouth-watering cat-shaped chocolates which for me at the time were the greatest of all life's sick-making pleasures: I felt their absence keenly. 'But *why*', asked a schoolboy contemporary in what was a predominantly Roman Catholic canton of Switzerland, 'do you give up *anything*? You're not a Catholic.' It was my first introduction to the erroneous myth that, Anglo-Catholics apart, on the whole Protestants were not obliged to eat fish on Fridays, or expected to observe the Lenten period of self-denial. It was also the first time that I was made aware that denominational differences could determine one's approach to God through worship. And it puzzled me.

My own upbringing was catholic in the full sense of the word. Born into the Roman Catholic faith, but later to become a High Anglican, my mother married my father who was a low churchman of the Nonconformist school. She was a regular attender at Mass which she pronounced with a long 'A'; he seldom took Communion. But both knelt together, prayed together, conscientiously acknowledged the forty days of Lent, and taught me to follow suit. Consequently, when in later years I was asked by a bishop to reveal my 'churchmanship', I looked blank. To me 'churchmanship' was the title of yet another book written by Stephen Potter; and I said so. Eventually I was confirmed into the Anglican communion,

but at no time was I influenced or coerced parentally into my choice of denomination. As my father said on more than one occasion: 'There is too much churchianity, and too little Christianity.' However, there are members of the clergy who take the vexing question of churchmanship a little too much to heart. These are they who bend over backward in the pulpit to avoid controversy but inevitably end up with one foot in the font as a result of trying to steer a middle course: like the cleric of whom G. W. E. Russell wrote in 'Lines from a Paris Magazine', who stated:

> I am a loyal Anglican,
> A Rural Dean and Rector;
> I keep a wife and pony-trap,
> I wear a chest-protector.
> I should not like my name to be
> Connected with a party;
> But still my type of service is
> Extremely bright and hearty.
>
> To pick the best from every school
> The object of my art is,
> And steer a middle course between
> The two contending parties.
> My own opinions would no doubt
> Be labelled 'High' by many;
> But all know well I could not wish
> To give offence to any.
>
> One ought, I'm certain, to produce
> By gradual education

A tone of deeper Churchmanship
 Throughout the population.
There are, I doubt not, even here
 Things to be done in plenty;
But still – you know the ancient saw –
 'Festina lente – lente'.

I humbly feel that my success,
 My power of attraction,
Is mainly due to following
 This golden rule of action:
'See us from all men's point of view,
 Use all men's eyes to see with,
And never preach what anyone
 Could ever disagree with.'

But to return to higher thoughts. For both my parents, Easter was the highlight of the Christian calendar, the one day of the year when Christians of all persuasions share in the joy of the risen Christ and the promise of eternal life; the day when, after the melancholy of Good Friday, altars are stripped of their purple shrouds, churches are filled with the colours and fragrance of spring flowers, and the Alleluias ring out. It is the most glorious of days and one to which I look forward with all my heart, and of which I have a sheaf of happy memories. And none more so than those of the Paschal services of the Greek Orthodox Church which I attended in Dodecanean villages. One stands out in particular: that of Easter 1978 in the coastal village of Kardamena in the island of Kos. But that was not the first time I had been to the church there. My initial participation in an act of worship under its

turmeric coloured dome was during the previous year. I remember it well, not only for the beauty of the service, but because it was the only church in which I have ever seen change taken from an offertory plate.

In those days, Kardamena was no more than a small fishing village where the number of visitors could be counted on one hand. Consequently, all one's movements were logged with considerable accuracy and interest. Mine were no exception; my first attendance at church on the Sunday, a week after my arrival, did not escape notice; or comment. Hesitantly I went in through the front entrance, and stopped. From inside came the sounds of men's voices raised in harmony, and I was hit by the smell of incense as I waited behind two women who bought candles from a reception committee in charge of a huge plate filled with drachmae. For a short second the eyebrows of the keepers of the plate went up as they recognised me, and then – '*Yasu* Yanni!' they cried, using the Greek equivalent of John, '*Ela! Ela!*', and escorted me in. I had seen them in the village but I had not met them; however they knew me by name.

As I entered, the heads in the rear rows turned toward me and elbows worked overtime as the news was passed on, nudge by nudge, whisper by whisper and row by row until I reached my seat. '*Heréte!*' said the man next to me, 'Greetings.'

The church was nearly full. On one side were the women, their heads shawl-covered, and on the other were the men, their faces free from the customary week-day stubble, and stiff in their Sunday best. Standing, or sitting on wooden chairs, they crossed and re-crossed themselves in the name of Christ as, from a lectern in the front, the village barber, pink and

tenor-high and leading his male choir of three, responded unaccompanied to the bass of the baker opposite as they sang together in praise of God, their jowels quivering to produce their vibratos. On and on they sang, filling the church with glorious sound as page after page of the great books of prayer were turned by their helpers. There was never a silence, and in the body of the church there was always movement as people came and departed.

Along the sides of the church sat the elders of the village, perched high in wooden stalls, their arms resting on tall supports. Never glancing to the right nor to the left and never moving unless to cross themselves or clean their ears – a pursuit which seemed to be a popular Sabbath occupation – they leaned forward intently, staring fixedly toward the altar. They looked like stone carved griffins or Cappo di Monte figures.

From time to time the *papas*, the priest, appeared in splendid vestments and, attended by unrobed acolytes dressed in logo-inscribed T-shirts, intoned the litany and blessed the congregation as he toured the church, waving his censer towards us. At one point he was overcome with a paroxysm of coughing.

'*Po! po! po!*' said my neighbour, shaking his head, 'too many cigarettes. He smokes forty a day – this always happens.' 'Yes,' said the man in front of me, half turning as he made the sign of the cross, 'he should give it up.' The *papas* recovered, returned red-eyed to the privacy of the sanctuary, and blew his nose vigorously. A party of thirty or forty little girls, cotton fresh in pink and white floral dresses, rustled in

like a spring breeze and made their way to the front and gathered around the barber's lectern; and an equal number of little boys, all newly scrubbed and smelling of soap, did similarly on my side but with less delicate tread. The *papas* appeared again, had another coughing fit, blessed the new arrivals, retired, and a few minutes later two painted screens moved by unseen hands came jerkily together in front of the altar. The service was over. There was a concerted rush to grab pieces of bread – a blessed gift from the *papas* – from a large wicker basket placed near the side door, and then everyone streamed out; but not before every male in the church had said good morning to me and shaken me by the hand. I had been greeted with curiosity and smiles when I arrived, but I left feeling doubly warmed and welcomed; I had become part of a family.

I pondered on that on my way to my breakfast. I tried hard to recall when a similar welcome had been given to me in the past when I had visited a strange church in my own country. Unfortunately I could not. We may not clean our ears with matchsticks during the Creed in rural England but we are not so quick to open our hearts to strangers.

Later that day I met the *papas* in the street. Out of his finery he presented a very different picture to that which I had seen in church. What I saw was a small, rather tatty man with an abundance of grey beard and, as far as I could determine through the carpet of hair, a kind face with astute, twinkling grey eyes. His black robes were badly in need of dry cleaning and his general appearance was that of a shopsoiled Father Christmas in mourning.

'*Heréte*!' he said, when he recognised me, 'it was good to see you in church this morning! But could you understand the service?'

'About half,' I said.

'*Thenbirazi*,' he said, patting my arm, 'never mind! You understand half but you get all the blessings, *ne*?' He laughed wheezily and fumbled under his robes for a cigarette. 'You will come again to Kardamena?'

'Yes,' I said, 'I think so – many times. But especially I should like to spend Easter here.'

'Ah yes, my friend,' he said, accepting a light from me, 'that is the time – especially for the Church! That is when we say "*Christos Anesti! Christos Anesti!* Christ is risen!" '

'I know,' I said, 'I know: but tell me, *pater* – if I come to church at Easter, will you be able to give me Communion?'

'But of course,' he said, 'why not? We are one Church are we not? You are a Protestant, *ne*?' I nodded. 'Then there is no trouble,' he said. He paused to draw on his cigarette. 'Only one, small, small problem: You will have to go to the Bishop in Kos to get his permission in writing for me to give you the Cup; but there is no worry.'

'I see,' I said, 'but it has to be done through the Bishop?' 'Oh yes,' he said, inhaling again, 'yes. Everything has to be done through the Bishop. In fact, my friend, in Greece we have a saying, and it is this: in life *we* are under the *bishops*, but in death – ' and here his eyes twinkled wickedly and he pointed downward, '*they* are under *us*! *Yasas*!' And off he went, wheezing at his own irony.

I never did get the Bishop's permission in writing; but I did return to Kardamena for Easter.

EASTER!

Can there be any day but this,
Though many sunnes to shine endeavour?
We count three hundred, but we miss
There is but one, and that one ever.

Since George Herbert wrote those words, nearly four hundred years have passed. Now, in our cities, this 'day of days' is more a cause for secular celebration than religious observance. Despite the premise that Britain is a Christian country it would be more accurate to say that it is a country in which there is a minority of professing Christians and an even smaller number of practising Christians. Now, to the majority, Holy Week is just another week out of the fifty-two in the year, and Good Friday just another public holiday on which to clean the car. It is no longer unfashionable not to go to church at Easter, and Mammon wins hands down. For aught I know a similar pattern is followed in most cities in Christendom, including Athens; but not so in the rural communities in Greece. There, Easter is the festival of festivals.

The date for the celebration of Christ's resurrection by the Greek Orthodox Church is at variance with ours. They still adhere to the Julian calendar and in 1978 Easter Day fell upon April 30th, five weeks or so after ours. But that is not the only marked difference: there the religious significance of the occasion is observed much more strictly than in Britain.

I arrived two days before the Solemn Week leading to Easter Day and to a welcome which stirred my heart. Vasili, a reprobate fisherman friend of mine, was there; so was

Michaelis the hoarse-voiced taverna owner with whom I had spent many happy hours during my previous visit; and so too was Pavlos, the village repairer of bicycles. All embraced me in the middle of the main street, and bottles appeared as if by magic. Then, after a three-hour sleep and a bear-hugged tour of the village, I supped with them in Michaelis' taverna off six large fish supplied by Vasili, a huge salad, and several bottles of retsina donated by Pavlos the Bicycle.

After my fourth fish I pushed my plate away. Vasili looked at me inquiringly. 'What is the matter?' he asked. 'Is it not good, this fish?'

'Yes,' I said, 'It is very good but I have had enough.' '*Oche*!' he said, spearing the fifth and putting it on my plate, 'No! No! No! You must eat all you can! *Sosta*?' he inquired of the rest of the table, 'true?'

'*Sosta*,' they choroused, 'you must eat all you can!'

'But why?' I asked. 'Because, Yanni,' said Vasili soulfully, 'from Monday until Easter Day you cannot eat fish.'

'Nor meat', said Michaelis, annexing the sixth mullet and tearing it in half. 'Nor eggs,' said Pavlos the Bicycle, falling on the remainder and continuing the recital of the diet sheet for the coming week through a mouthful of bones, 'nor eggs, milk, cheese, yoghurt – nothing that comes from an animal.' 'Nothing!' endorsed Michaelis, 'that is the custom.'

There was silence to allow me to digest these hard facts of life and I stared hard at the table. I was a little dismayed. I was anxious to take part in all their Easter celebrations but, having enforced my own period of self-denial during our Lent five weeks beforehand, I saw no reason why I should go into repertory.

It was Michaelis who broke the silence. 'Do you not fast in England and hurt your stomach before Easter?'

'Some of us do,' I said. He pursued the question. 'Do *you*?'

I nodded. 'What', he asked, 'do you do?' 'Well,' I said, 'when we celebrated Easter a little while ago, I gave up drink.'

There was a horrible sound as both Vasili and Pavlos choked on their retsina. 'You did *what*?' said Vasili, in a voice barely above a whisper.

I repeated my confession. 'I gave up alcohol', I said.

Had I said I had given up breathing the effect could not have been greater. Vasili looked at Pavlos and Pavlos looked at Vasili. Then they both looked at Michaelis; and then they all looked at me.

'*That*', said Michaelis, 'is something we never do.'

'Never', said Pavlos.

'Never', said Vasili. He was badly shaken. 'And if you have done this thing,' he continued, his eyes still filled with a mixture of horror and admiration, 'if you have made this sacrifice, then you can eat anything you wish. *Sosta*?'

'*Sosta*!' they said, 'anything. And nobody will be offended when you eat the forbidden food.'

I was much comforted by their blessing and their assurances. However, what they did not say was (a) you can eat anything you like − if you can get it; and (b) nobody is going to be offended − if they know the facts. Had they given me this additional information I should have been better prepared to face the challenge with which I was confronted on the Monday.

'*Yasu*! Sylvi,' I said brightly to the plump, full-bosomed motherly woman who with her husband Yanni the Barber

(who sang in the choir) owned the pastry shop where I went for my breakfast, 'yoghurt and honey please, as usual.'

Yanni drew in his breath sharply, looked quickly at his wife and left hurriedly for his own establishment. '*Yohourti?*' said Sylvi, as if she had never heard the word '*yohourti*? Ah, *yohourti*! Yes! yes! yes! *yohourti*! No! There is no *yohourti* today. No,' she said, 'unfortunately the ewe has broken down. And', she added, not wishing to hurt my feelings by telling me the truth but leaving me in no doubt as to the immediate future, 'I think it will be broken down until Sunday.'

I tried four establishments before I broke my fast. In the fifth, presumably owned by a Dissenter, I met with success: I got my yoghurt. But I was watched keenly by disapproving eyes as I broached it, and by the last spoonful it had turned to ashes.

As I was to see, most of Kardamena kept rigidly to the daily intake of fruit, salads, olives, bread and squid, and by the end of the period of abstinence one could hear the village reverberating to the sound of rumbling stomachs. I was impressed greatly by this unswerving dedication. However, the low protein diet washed down by the permitted and uninterrupted flow of ouzo and retsina also resulted in many of the faithful reacting slowly to the events of the day and walking as if on cotton wool and, in one case, actually sliding down the wall of the *papas'* house, where, upon reaching the ground, he remained in a sitting position until he was assisted to his own quarters by the local, and temporarily underemployed, butcher. But that week was an eventful one in other respects.

Every day I saw Easter preparations of some kind taking

place. On the Tuesday and Wednesday of Holy Week I watched women, young and old, carrying yard-square black baking trays filled with uncooked pastries to Lefteris, the Baker, at the end of the main street. These were the *biscota pascalina*, the Easter biscuits, shaped in plaits and curls, and alphas and omegas, and honey-sweet when cooked. Up the street the women would go in twos and threes, each with a tray balanced on either hip, then back they would come in line abreast with rolled up sleeves and reddened arms, gossiping as they walked. Later, much later, they would make a return visit to the bakery and come back with the pastries golden brown and oh! – the whole street smelt of fresh baking.

There were also the *teropita*, circular cheese pies half an inch thick. Load after load of those were carried to and from Lefteris's on that Tuesday and Wednesday; and the women who were not thus engaged were busy hard-boiling eggs and dyeing them in reds and greens and yellows and blues. The shells of some were decorated with exquisite transfers of leaves, and everywhere I went that week I was given one, but with strict instructions not to break it before Easter Day.

It was on the Tuesday that the goats and lambs arrived in the village. I watched them being unloaded from a truck. They were dumped unceremoniously in doorways, hog-tied and bleating. As the morning wore on their cries lessened, their numbers thinning as they were taken to the butcher's shop, to reappear later either entire but naked and slung across the backs of cyclists, or jointed and bloody in blue polythene bags; and another smell wafted through the streets of Kardamena as the skins were hung to dry. It was very basic, but all part of the Greek Easter scene. So too was the Wednesday

procession of the black-shrouded widows. Late in the afternoon I watched them making their way slowly down the street *en route* for the mile-long journey to the cemetery. For some their grief was still fresh. For others, time had blunted the initial pain of sadness; but all remembered.

Each carried a wreath of mauve and white plastic blooms and a spray of real flowers – the huge white arum lilies carefully grown and nurtured for that very purpose – which they would put on the graves, then trim the wicks of the tombs' night-light candles, say a prayer in front of a photograph of their dead and then return to the living community.

Some would go to church that evening; others would stay at home with their thoughts; but none would be alone. The elderly are not left in loneliness and obscurity in Kardamena. Each family looks after its own. Old fashioned though the word may be, there is a 'togetherness' there.

That facet of life was particularly noticeable during that week when, with very few exceptions, all went to church on the Thursday, Friday and Saturday. Doubtless the degree of piety varied, but the rule was observed and at some time or another most put in an appearance during the three-and-a-half-hour-long services. But it was at midday on the Thursday that I was given a simple, poignant reminder of the sacrifice at Golgotha.

I walked out of the village and into the fields, and lunched off black olives and bread in a byre with a farmer named Stelios and his wife Maria. Together we sat on upturned buckets and dipped into a communal tin.

'Tonight', he said, 'you will be at church – *ne*?'

'*Ne*,' I said, 'yes. And you?'

'Of course,' he said. 'Tonight is when they put the nails through Him. You know – Bang! Bang! Bang!'

It was a crudely expressed thought; but it remained in my memory longer than many sermons. And so has the gesture of his wife.

Growing close to the shed in which we ate was a bush of Christ's thorn. As I left she stooped down, plucked a flower from it and pressed its sticky stem into my shirt. 'There!' she said, 'Christ's blood is in those petals; and look!' She pointed to the centre of the tiny red flower. In it was a droplet of moisture. 'You see?', she said, 'one of His tears which He sheds for all of us.'

I am not over-emotional, but as I turned away from them, I had to blink away one of my own.

At a quarter past six that evening the first worshippers started to make their way to church. By the time I took my place at seven o'clock there were thirty or so present, listening to the bass, magnificent melancholy of the choir as, on their Holy and Great Thursday, they sang the litany of the Crucifixion.

As they sang, filling the church with sadness and passion and with ever increasing power, so the numbers grew until, with the building reverberating to the sound of nails being hammered home as the judicial murder of Christ was re-enacted, it had swollen to bursting point. Then, as the great black cross with the crudely painted, garish figure of Christ stretched upon it was lifted and carried to the centre of the church, and the choir's voices were raised to a new peak of lamentation, so wreath after wreath of plastic flowers was hung upon it until the outstretched arms and bloodied head could

be seen no longer. Men and women, I remember, pressed forward to kiss the effigy's feet, some dry-eyed and others weeping.

I remember, too, the airlessness; the pungency of incense; the stifling heat from the black-shrouded candelabra and the hand-held candles of the sweating congregation. We were packed like sardines. Farmers and shepherds, taverna owners and fishermen, policemen and soldiers, shopkeepers and merchants, children in arms fighting to keep awake, old men who had lost count of their Easters and confessions – all were there. It was very emotional.

When the service was over I walked to a taverna on the shore, together with its owner. She opened up for me and brought me a drink. Gradually others drifted in. She switched on the television and in silence her audience sat and watched a service from Athens. She gave me an egg when I left. It was blue and had a yellow flower traced on it. 'Two more days', she said, 'and then, thanks be to the God, we can say goodbye to squid! *Kalinichta!*'

As I walked back to my *pension*, the sea was quiet and as calm as a mill-pond. It was almost as if it too felt the need of silence. But my head was full of the thoughts of what I had seen. The drama depicted in church was one which had taken place two thousand years ago when Christ was crucified. But not for the last time. Daily, I reflected, mankind crucifies Him afresh; in Belfast and Beirut; in our own home towns and cities; and on His own ground in Palestine. And I thought of a poem written by one, Richard Le Galliene. He called it 'The Second Crucifixion':

Loud mockers in a roaring street
Say Christ is crucified again:
Twice pierced His gospel-bearing feet,
Twice broken His great heart in vain.

I hear, and to myself I smile,
For Christ talks with me all the while.

No Angel now to roll the stone
From off His unawaking sleep,
In vain shall Mary watch alone,
In vain the soldiers vigil keep.

Yet while they deem my Lord is dead
My eyes are on his shining head.

Ah! never more shall Mary hear
That voice exceeding sweet and low
Within the garden calling clear:
Her Lord is gone, and she must go.

Yet all the while my Lord I meet
In every London lane and street.
Poor Lazarus shall wait in vain
And Bartimaeus still go blind;
The healing hem shall ne'er again
Be touched by suffering humankind.

Yet all the while I see them rest,
The poor and outcast, on His breast.

No more into the stubborn heart
With gentle knocking shall He plead,
No more the mystic pity start,
For Christ twice dead is dead indeed.

So in the street I hear men say,
Yet Christ is with me all the day.[2]

The next evening I went to church again. Once more we stood shoulder to shoulder in the sweltering heat and once again emotions were very high. The cross had gone and in its place was a stretched gold-trimmed velvet cloth. Mounted upon it were pictures of the dead Christ and His mourners – Mary His Mother, John the Beloved, Joseph of Arimathea and Mary Magdalene. A seemingly never ending queue moved forward to kiss the faces of the figures, and an elderly man with a miniature Beefeaters gin bottle filled with water took it to the *papas* to be blessed. Then, as the service ended, each of us, holding a lighted candle and headed by the *papas* and the choir, followed the ornate bier of Christ from the church and processed slowly through the village.

I kept company with them for a while and then broke away to have a bird's eye view of the scene from the flat roof of my *pension*, and from there I saw, not a column of people, but a thousand fireflies. Ten minutes later I became one of them again, and as we wended our way through the narrow streets, from the doorways of houses on either side women splashed us with rosewater and called out blessings on us – '*Yasas! Yasas!*' – and so we moved on until the whole of Kardamena had been walked.

Near to midnight I fell out and leaned against the corner of a house. Gradually the flickering candles moved out of sight and the voices of the choir grew fainter and fainter as the *papas* led them back to the church. From its belfry the bell tolled for the last time that day. Twelve times it rang and then it,

too, was silent. Suddenly Kardamena became very quiet. Friday, the day of universal mourning, had died. But the next night, all was joy and the singing of the choir surpassed anything that had gone before.

The evening service was magnificent that Saturday. It began at ten-thirty and an hour later you could not have put a knife-blade between us. Minute by minute more and more tried to join us but could not gain admittance and had to be content with listening to the service through loud-speakers outside. Toward the latter part, women and men pushed and stumbled past other worshippers as they struggled to get to the doors for air. In front of me the head of a young woman flopped forward as she fainted but was held up by the sheer pressure of her neighbours' bodies. Gently and gradually she was eased toward the side door, where she sat with others on the stone floor of the porch and recovered.

Near midnight the singing reached a climax. The *papas*, robed in all the splendour and richness of the Easter trappings of the Orthodox Church, swung his censer and poured out his blessings, the excitement in the congregation mounted; and then, on the stroke of twelve, in a solid, sweating, chattering phalanx we left the church and went outside. And as the *papas*, followed by the choir, reached the top of the flight of stone steps leading to the church's gallery and cried with outstretched arms: '*Christos Anesti*! Christ is risen!' so the night sky erupted and exploded in a display and cannonade of fireworks.

'*Christos Anesti*!' cried everyone, '*Alethos Anesti*! He is risen indeed!' and embraced the nearest to them, for this was the *Meres Agapis* – the Day of Love. Everyone kissed everyone.

Fat old women I had waved to in the fields, modest young ones who had hitherto been shy, Vasilis and Kostas and Yannis and Giorgos – all surged in a sea of emotion and kissed me and each other as if none of us would meet again for a thousand years. And all the while the mortars and the roman candles banged their salutes in fiery fountains to the Risen Lord, and the rockets seared the sky.

I am still warmed by the memories of that Easter week. I gained much from it. But greatly though I love Greece my roots are in England, which is still a green and pleasant land and where Easter is still a very special day for those who observe it – the Day of the Risen Christ.

I shall always look forward with impatience to that day. To when, early in the morning, I cross the playing fields of Harrow School, climb the winding hill to the church of Saint Mary's where Beckett prayed on his last stop to Canterbury and martyrdom, and take my place in an uncomfortable pew under the high timbers of its roof carved from the oaks of Harrow's vanished forests. Doubtless it will be cold. Inevitably it will be raining, but it will be a glorious day. It will be the day when the rafters echo with shouts from the Hebrew: 'Alleluia! Praise ye the Lord!'

<div align="center">Amen</div>

Sources

Page v

Margaret Cropper, *Collected Poems* (Titus Wilson & Son, Kendal).

Birth

1 Laurie Lee, 'Christmas and the Child', *This Time of Day*, BBC Radio 4, 21st December 1964 (N.T. 10359, Sound Archives).
2 G. K. Chesterton, *Collected Poems* (Methuen, London).

Enigma

1 Eric Millward, *Dead Letters* (Harry Chambers, Peter Loo Poets, Treovis Farm Cottage, Upton Cross, Liskeard, Cornwall PL14 5BQ).
2 John Betjeman, 'Christmas' in *A Few Late Chrysanthemums* (John Murray).

Growing Up

1 Mary Spain, *Between the Lines* (Evergreen Books, Abbeymount, Edinburgh 8).

2 Hilaire Belloc, *Yet More Comic and Curious Verse*, ed. J. M. Cohen (Penguin Poets).

Schoolmasters

1 Rupert Brooke, 'The Soldier' in *Poems of Today* (Sidgwick & Jackson).

Love

1 Albert Schweitzer, *Memories of Youth* (Allen & Unwin).
2 Thomas Brown, translation of Martial's Epigrams, *Works* (1719).
3 D. H. Lawrence, 'The Effort of Love' in *Selected Poems* (Penguin, in association with Heinemann).
4 Helen Waddell, *Medieval Latin Lyrics* (Penguin Classics 1952).
5 Christopher Marlowe, 'The Passionate Shepherd to His Love' in *Cassell's Anthology of English Poetry*.

War

1 John Gillespie Magee, Pilot Officer, RCAF.
2 Helen Keller, *The World We Live In* (Methuen).

The Joy of Living

1 H. G. Wells, *The World of William Clissold* (Benn & Co.).

SOURCES

My God! Are You There?

1 W. H. Carruth (G. P. Putnam & Sons).

Simplicity

1 J. P. Morgurgo in *Yet More Comic and Curious Verse*.
2 James Weldon Johnson, 'The Creation', *God's Trombones* (Viking Press, New York, 1927).

Origins

1 Mary Spain, *Between the Lines* (Evergreen Books, Edinburgh).
2 Lewis Carroll, *Sylvie and Bruno Concluded*, Complete Works of Lewis Carroll.
3 Blackmore, *The Creation*, Book II.
4 Browne, *Essay on the Universe*, Book III.

Growing Old

1 Robert Browning, 'Rabbi Ben Ezra'.
2 Printed by the League of Friends of St Bernard's Hospital, Southall.
3 G. K. Chesterton, *Collected Poems* (Methuen).

Adieu – but not Goodbye

1 Christina Rossetti in *Cassell's Anthology of English Poetry*.
2 Mary Proctor, *Stories of Starland* (Potter & Putnam, New York; G. W. Bacon & Co., London, 1898).

Easter

1 G. K. Chesterton in *Cassell's Anthology of English Poetry*.
2 Richard Le Galliene in *Oxford Book of English Verse*
(Clarendon Press 1906).